Chicago's Historic Irish Pubs
IMAGES of America

ON THE COVER: George and Mary Shinnick, along with their son Donny, stand behind the bar at Shinnick's pub in Chicago's Bridgeport community. The bar is now in the hands of George and Mary's grandchildren. (Shinnick family.)

IMAGES of America
CHICAGO'S HISTORIC IRISH PUBS

Mike Danahey and Allison Hantschel

ARCADIA
PUBLISHING

Copyright © 2011 by Mike Danahey and Allison Hantschel
ISBN 978-0-7385-8391-4

Published by Arcadia Publishing
Charleston, South Carolina

Printed in the United States of America

Library of Congress Control Number: 2010936937

For all general information, please contact Arcadia Publishing:
Telephone 843-853-2070
Fax 843-853-0044
E-mail sales@arcadiapublishing.com
For customer service and orders:
Toll-Free 1-888-313-2665

Visit us on the Internet at www.arcadiapublishing.com

This book is dedicated to the Clarke family of West Dundee via Dublin, whose hospitality and adventures in and around Chicago led us to the tales told in this collection.

Contents

Acknowledgments		6
Introduction		7
1.	Irish Pubs and the Birth of the City	9
2.	Politics and the Pub	21
3.	Tales from Chicago's Historic Irish Pubs	33
4.	The Pub as Immigrant Experience	69
5.	Music and the Pub	85
6.	The Modern Irish Pub	105
7.	Finding Your Local	115
8.	The Perfect Pint, the Parting Glass	123
Online Resources		127

Acknowledgments

This book is by no means intended to be a listing of every Irish pub in the city or even every significant Irish pub. Rather it should be seen as a sampling of the kinds of stories every Irish pub has to tell. As such, we are indebted to many of the owners of Chicago's fine establishments who shared their families' histories with us.

We also would like to thank city historian Tim Samuelson, Richard Lindberg, Dave Hoekstra, Tom Boyle, Brian Donovan, the staff of the Irish American Heritage Center, Cliff Carlson of the *Irish American News*, the Southeast Chicago Historical Society, Ed Kane of Louis Glunz Beer Inc., and all others who provided sources and background on significant Irish pubs. Arcadia Publishing, especially Melissa Basilone and John Pearson, helped bring this story to life.

A version of the Murray's story told in The Pub as Immigrant Experience originally appeared in Elgin's *The Courier-News*.

Introduction

One might think that being asked to provide a foreword to a book on Chicago's historic Irish pubs is a rather dubious honor. Was I asked because of my role with the Irish American Heritage Center (where a good part of the research for this book was done) or because I have a reputation for knowing my way around the inside of a pub? As someone who takes great pride in his Irish heritage, I hope the honor was for both reasons.

The pub is a major force in the story of the Irish people, both in Ireland and America. The Irish as a people have stereotypically been linked to drinking and bars for generations and often in a negative way. But rather than try to put the stereotype behind them, the Irish embrace this part of their culture. In Ireland, pubs often became the places where the Irish gathered and developed their musical, political, and literary might. In this country, the pubs became a place for immigrants to connect with family members and other immigrants, a place to find a job, a place to play some music, or just somewhere to provide a small sense of home.

With millions of Irish immigrating to the United States and producing generations of Irish Americans, the Irish pub became a fixture in American life. Today all anyone has to do is stroll down Lincoln Avenue, Halsted Street, Clark Street, or any of the hopping neighborhoods in Chicago and there is an "Irish bar" on almost every corner. As you read through the book, you'll benefit from the painstaking research by the authors to uncover a little of the history and the pictures that tell the story of Chicago's Irish pubs.

Growing up in Chicago, I was the youngest of a large Irish family. My mother taught Irish dance; my father was a member of the Shannon Rovers pipe band. We were members of the old Shamrock American Club and part of the founding generation of the Irish American Heritage Center. We are Irish American and proud. And despite my mother's good teachings and best efforts, Irish pubs have played a big role in my life. As a kid, I can remember the days when the old Murray's Pub would paint part of Elston Avenue green for St. Patrick's Day and when Bobby Ryan broadcast The Irish Hour live from the old Abbey Pub. I remember when my older sisters worked at the legendary Kilkenny Castle. They even met their husbands through that pub and its owners, the Brady family.

For older generations, the pub was the place at the corner of the street. For my generation, the pubs were everywhere. We went to the north side, south side, downtown, Wrigleyville, Lincoln Park, and helped to start the pubs at Gaelic Park and the Irish American Heritage Center. I remember dancing and singing at The Thatch back in the day and singing along with Jimmy and Peter downtown at Kitty O'Shea's. I remember kneeling down for a "quiet moment" at the Wolfe Tones show at The Abbey and rocking out there when The Drovers were all the rage around town. We made road trips down to Cork and Kerry and Reilly's Daughter. And we helped places like Kelly's and Durkin's stay relevant for new generations.

The story of Chicago's Irish pubs is much more than just a story about bars. A true Irish pub weaves itself into the fabric of the neighborhood and the life of the people who live there and

call the pub their own. Irish pubs are often the first to step up and host benefits for patrons and families in need. They're where we gather before and after weddings, wakes, and funerals. They're where we share our memories with great friends. For some, they're where we first tried to woo our future wives and spent several dates trying to overcome those first impressions. In short, the story of the Irish pubs is the story of the Irish themselves in Chicago.

As you immerse yourself in the pages of this book, the pictures will bring you back to some of the more legendary Irish pubs in Chicago's history. You'll get a feel for the workingman's pubs of the early 1900s and catch a rare glimpse into the heydays of Butch McGuire's and Division Street. The stories of the pubs are as unique as the story of Chicago itself. Anyone who has enjoyed a few jars in his day will find this trip down memory lane as satisfying as a proper pour of Guinness—and it might just prompt you to head out to your own favorite pub for a pint.

—Robert McNamara, president,
Irish American Heritage Center

One

IRISH PUBS AND THE BIRTH OF THE CITY

Just around the curve of a river, past rumbling trains and between rising bridges, sits the birthplace of the city of Chicago, a piece of land once known as Wolf Point. It was a meeting place for traders, troops, and travelers, a place to rest and have a drink, to exchange news heard along the road.

A tavern named for an Irishman was founded there in 1831, and a tavern named for an Irishman stands there today.

The son of an Irishman and a Potawatomie woman, Billy Caldwell was known as Sauganash, from a Native American word for "Englishman." Elected a justice of the peace in Chicago, Caldwell lent his nickname to the tavern Mark Beaubien built on the north branch of the Chicago River, according to A. T. Andreas's *History of Chicago from the Earliest Period to the Present Time*.

The Sauganash is long gone, as is Wolf Point, swept away by fire and progress and the passage of time. In 1912 the Great Lakes Building was built on the site as a mill, and in 1982, Mark Ryza and his partner John Sweeney opened Coogan's Riverside Saloon there.

In addition to its location, Coogan's takes its name from Irish Chicago history; John Sweeney's grandfather, Michael J. Coogan, owned a bar in the city called Coogan's before Prohibition.

The owners took pains to make their establishment the kind of place where its namesake would feel right at home, restoring the historic building's tin ceiling and lining its walls with photos of the city's birth and growth.

"It was a monster of project," Ryza said, shaking his head at the memory. "But we wanted it to have a turn-of-the-century feel because that's what the location called for."

This once-isolated spot, now surrounded by blocks of glass and steel, exemplifies the way Irish taverns, saloons, and bars are knit into the history of the city. Their stories are not merely the stories of drinking and carousing, but of friends meeting, politicians plotting, families building their legacies, and immigrants finding their way in the new world.

Billy Caldwell's plot of land, shown on this 1830 plat of the city, can be seen on site no. 22. (Chicago History Museum ICHi-34284.)

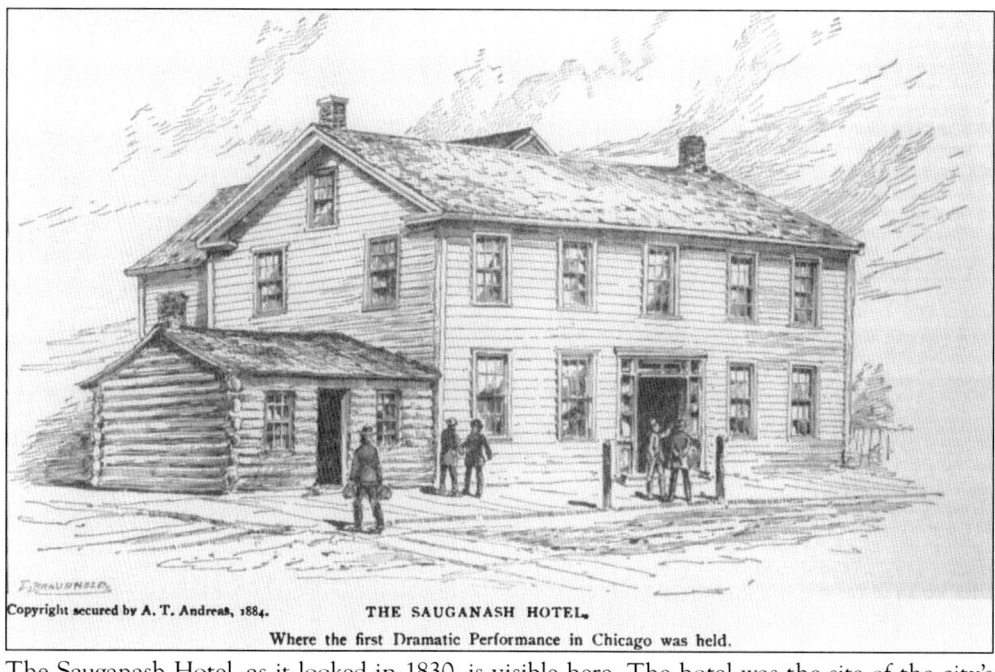

The Sauganash Hotel, as it looked in 1830, is visible here. The hotel was the site of the city's incorporation three years later. (*History of Chicago from the Earliest Period to the Present Time*, A. T. Andreas, 1884.)

The Sauganash site in the 1940s gave no indication of its history or significance. (Authors' collection.)

Coogan's Riverside Saloon is now a gathering place for bankers and brokers on their way home from work. Mark Ryza, asked why he opened a downtown bar instead of one in a city neighborhood, responded only slightly jokingly that "there's a limit to how crazy somebody's gonna get with his boss and his co-workers around." (Authors' collection.)

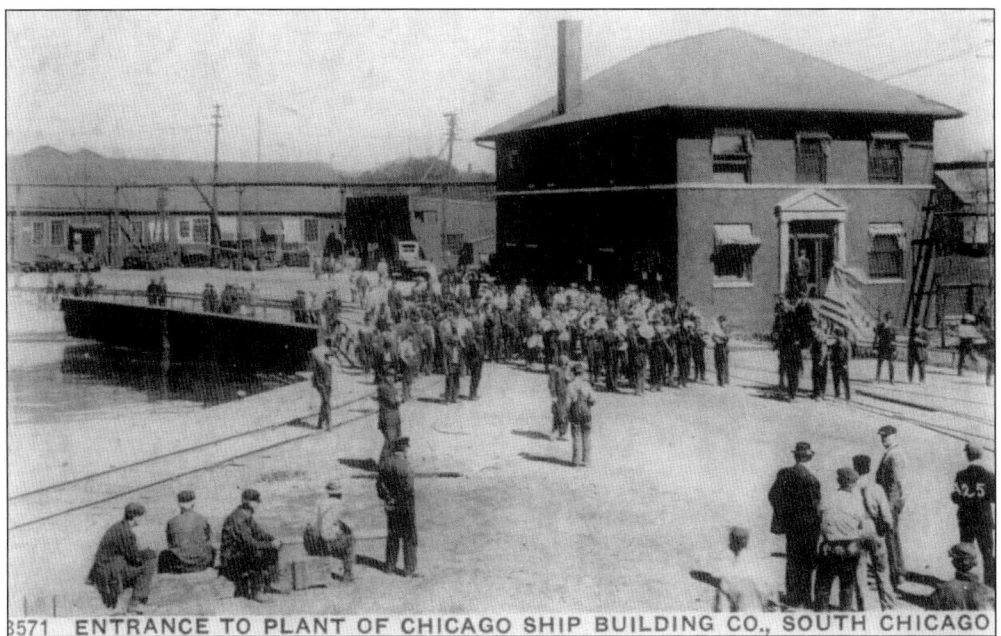
Germans predated the Irish in immigrating to Chicago, and their taverns were well-established by the time Irish laborers arrived. The Irish were drawn by the jobs in shipyards and steel mills. (Southeast Chicago Historical Society.)

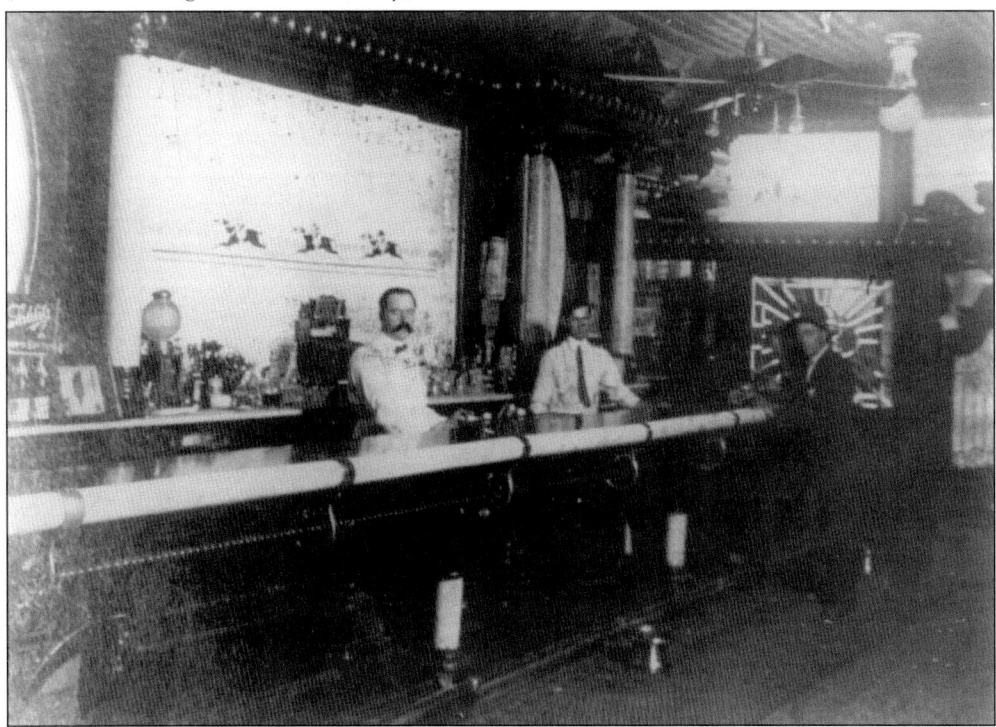
Though they first drank in German-owned establishments like the Kinney Marble Rail Bar, the Irish quickly built their own saloons, craving a place where they could re-create the social life they had left in their home counties. (Southeast Chicago Historical Society.)

This deed gave Patrick O'Sullivan three plots of land in 1895, which he purchased from the Pitzale family. O'Sullivan later opened a tavern in the neighborhood. (Southeast Chicago Historical Society.)

Taverns and saloons sprang up around workplaces, like those near the steel mills in the South Chicago community. Neil Duffy's bar can be seen on the right. (Southeast Chicago Historical Society.)

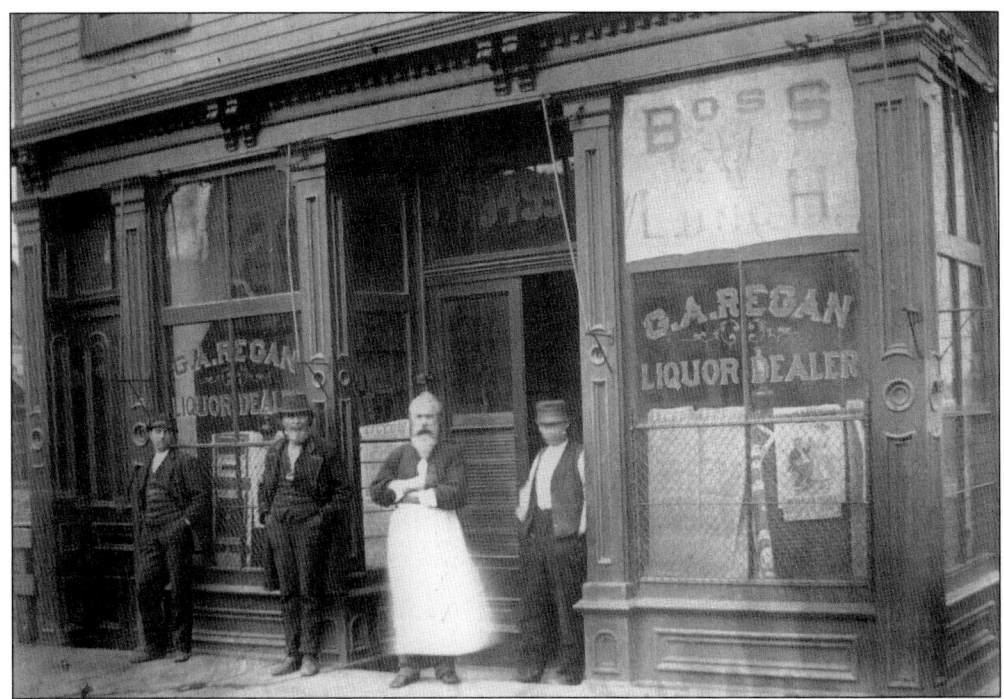
Before Prohibition, liquor dealers, distributors, and brewers often sold their products directly from storefront saloons like G. A. Regan's. (Chicago History Museum ICHi-32220.)

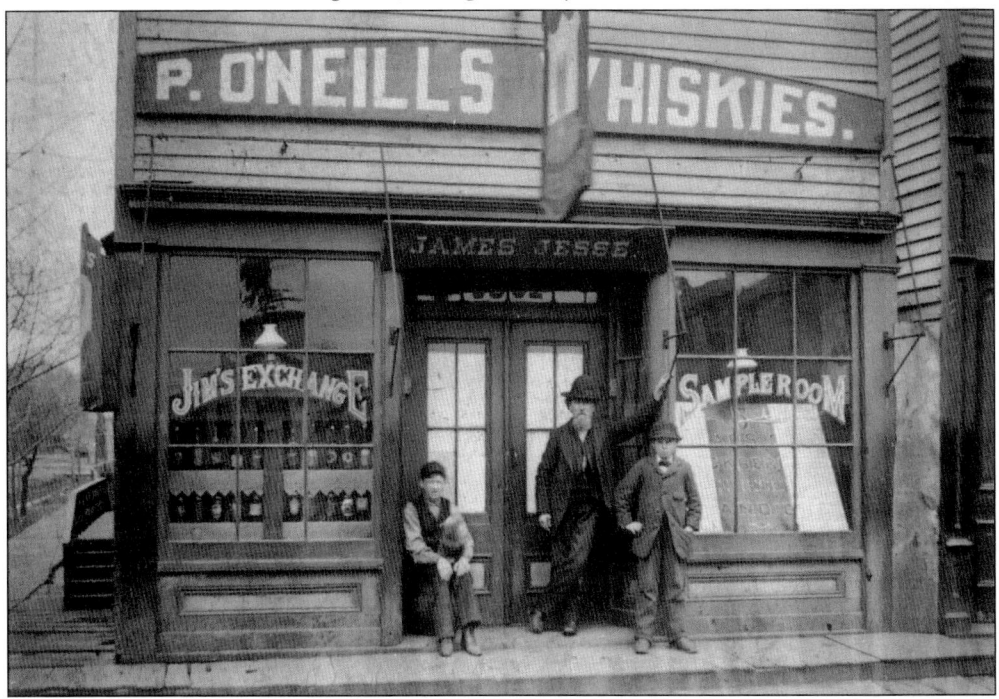
Early taverns were not places to linger over a pint with friends. Men were served standing at the bar, and women were able to enter only through a back door (if at all). (Chicago History Museum ICHi-21456.)

M. Sullivan's Sample House at The Wentworth Tavern, 5058 Wentworth Avenue, seen here in 1895, was both a tavern and a liquor distributor. (Chicago History Museum ICHi-62147.)

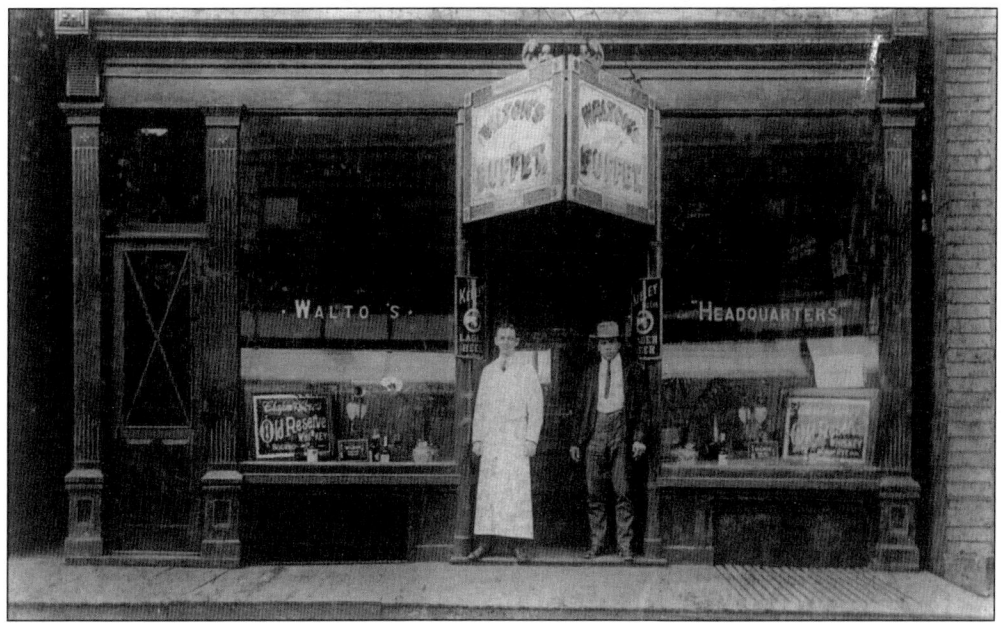

In addition to liquor, this saloon, Walton's, also served a buffet lunch. (Southeast Chicago Historical Society.)

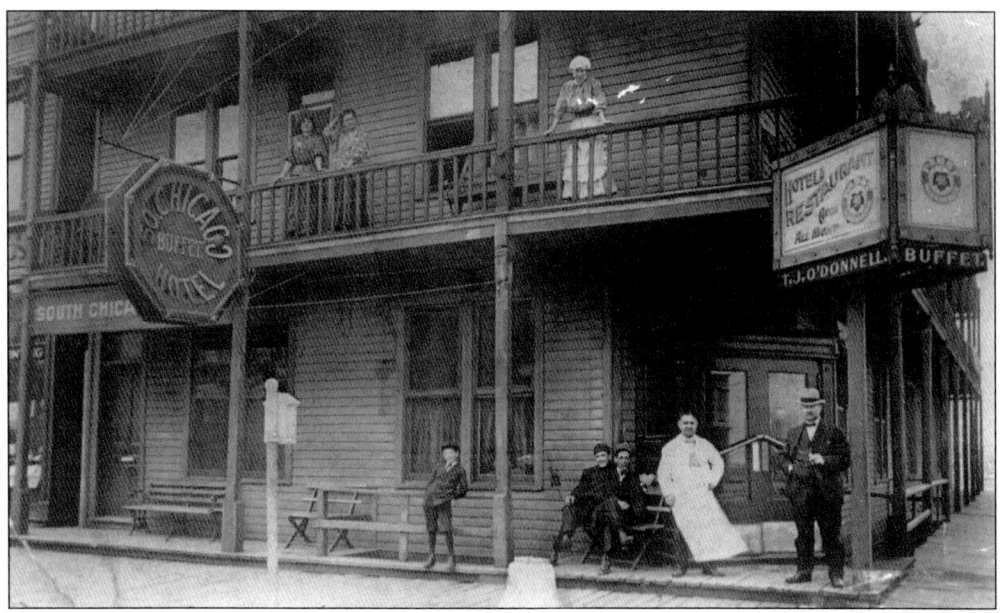

Inside Walton's, the city's aldermen often met to discuss business. It was known, said local historian Rod Sellers, as "the place to go if you needed to find out what was going on." (Southeast Chicago Historical Society.)

T. J. O'Donnell's South Chicago Hotel, which held a restaurant and bar, was a place where men could get drinks, dinner, and (on occasion) women. (Southeast Chicago Historical Society.)

Whiskey was a mainstay of most local taverns, and those taverns that did serve beer sold German beer from local breweries, as this 1890s photograph of a beer delivery truck shows. (Southeast Chicago Historical Society.)

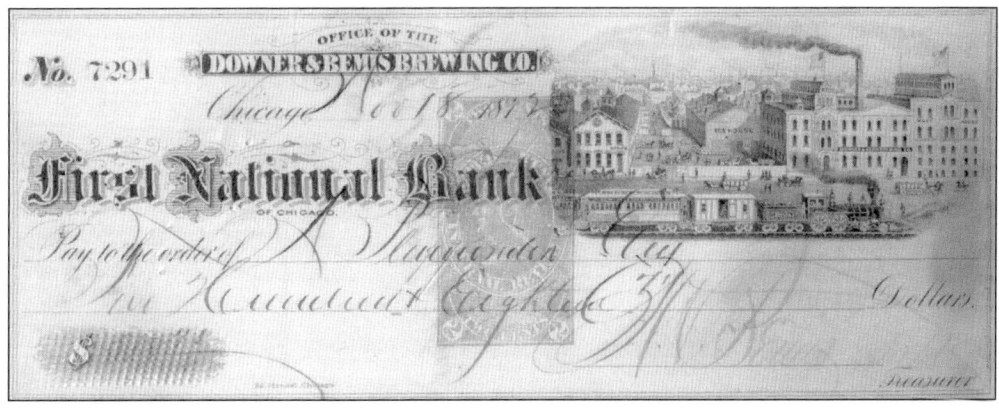

This check was issued from Downer and Bemis Brewing Company, one of the first Irish-owned and operated breweries in Chicago. Founded in 1865 and purchased in part by John H. McAvoy, an Irish immigrant from Newry, the brewery produced up to 100,000 barrels a year in its heyday. (Authors' collection.)

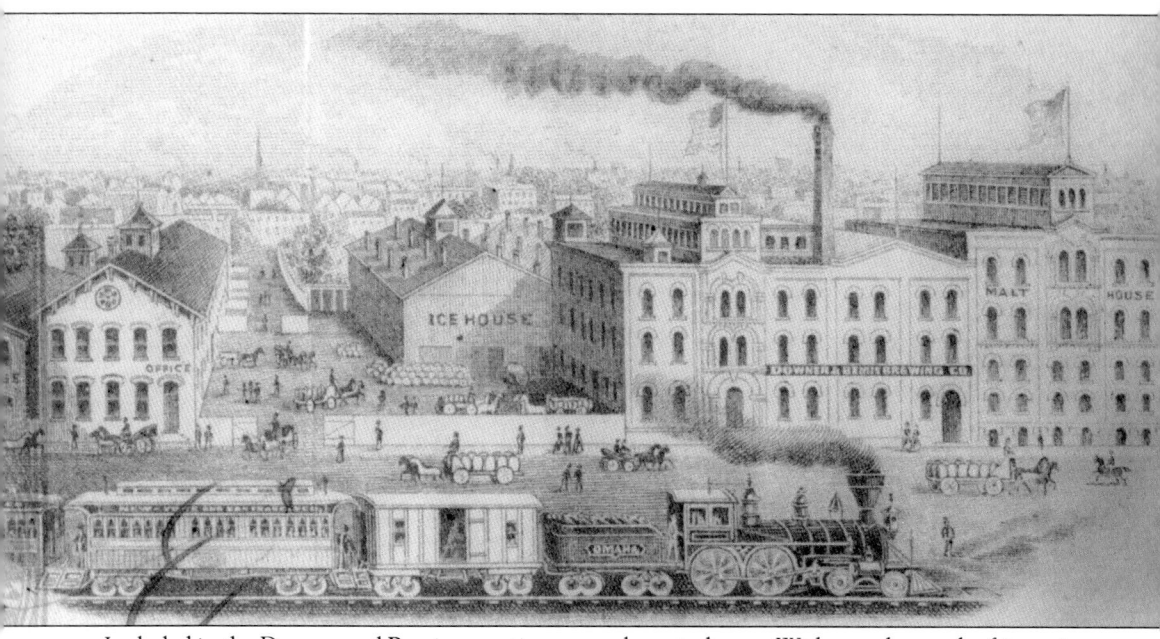

Included in the Downer and Bemis operations was a large icehouse. Without advanced refrigeration technology, beer could not be transported across long distances, so taverns served local brews. (Authors' collection.)

McAvoy later reorganized the company and renamed it the McAvoy Brewing Company, but it closed with Prohibition, according to taverntrove.com. The Frederick family later purchased the name, operating a brewery and saloon in Thornton, Illinois, until 1951. (Authors' collection.)

By the early 1900s, locally produced Irish beers were popular throughout the city. A sign for Keeley's beer can be seen in the lower left, above Ye Olde Time Inn in South Chicago. (Southeast Chicago Historical Society.)

Two

Politics and the Pub

Chicago is notorious for its machine politics. One of the men who helped build the foundation for that dubious reputation was an Irishman from New York. Historian Richard Lindberg tells the little-known tale of one of the Windy City's original bosses in *Michael McDonald: The Gambler King of Clark Street*, a must-read for anyone who wants to learn how "the city that works" took on a good many of the traits it has to this day.

McDonald wielded behind-the-scenes power and reigned as "King Mike" from 1868–1888. While McDonald had a gambling den of his own and a home among Chicago's ruling elite, taverns played a big role in how things got done.

"They were the places to socialize, to receive mail, to broker jobs, to vote in city elections and were the go-to destinations for the exchange of influence," Lindberg said.

According to Lindberg, after the Civil War, "the Irish filled a widening political vacuum simply because they could speak English, and the profession of politics was deemed unworthy by the socially conscious upper class Protestant 'bluebloods' who sent their sons to universities and encouraged them to go into the banking, manufacturing, retail, and investment businesses—and to shun public life, policing, and so on. McDonald was just that much smarter than most of his contemporaries and possessed greater organizational skills and business acumen."

McDonald made himself into a gambler king by being "the first to systematize the city gambling fraternity into a politically powerful syndicate linked to elective politics and city office holders," Lindberg said. While taverns were the scenes of backroom political deals and even voting, they were not pubs as most people identify pubs today.

"They were known by several names—saloons, concert saloons, and by the time of World War I, as taverns. Also, the Irish were not 'exclusive' to these establishments. The Germans operated beer gardens. Some of them had outdoor pavilions with attached dance floors and restaurants. Irish bars ran the gamut from simple, unpretentious basement dives with dirt floors and wooden planks propped up by barrels to elegantly festooned showplaces like the kind Hal Varnell kept on Randolph Street," Lindberg said.

In his book, Lindberg writes that "The (Chicago) *Inter-Ocean* reported on February 20, 1882, that there were '3,562 places licensed to sell liquor and not less than 1,500 unlicensed.' Tracing the root of the gambling scourge and the moral downfall of the city to the liquor trade, the paper went on to say that 'Many of these saloons have all the accessories of the darker vices that pollute the very fountain of society. They are fitted up with the most skillful appliances and contrivances for the perpetration of crimes so dark that they cannot be named.'"

Chicago being as it is, Lindberg notes that quite a few of the city's prominent businessmen and civic leaders leased their property holdings to gamblers. The influence the tavern held on political life in Chicago lasted "well into the 20th century. The generations of saloon politicians who held elective office continued to tread in this old-fashioned system until after World War II, when technology, that is the coming of television and home air conditioning, began keeping people indoors after work. After 1950, the number of saloons in Chicago began to decrease dramatically as a result, and with it the reign of the saloon boss ended," Lindberg said.

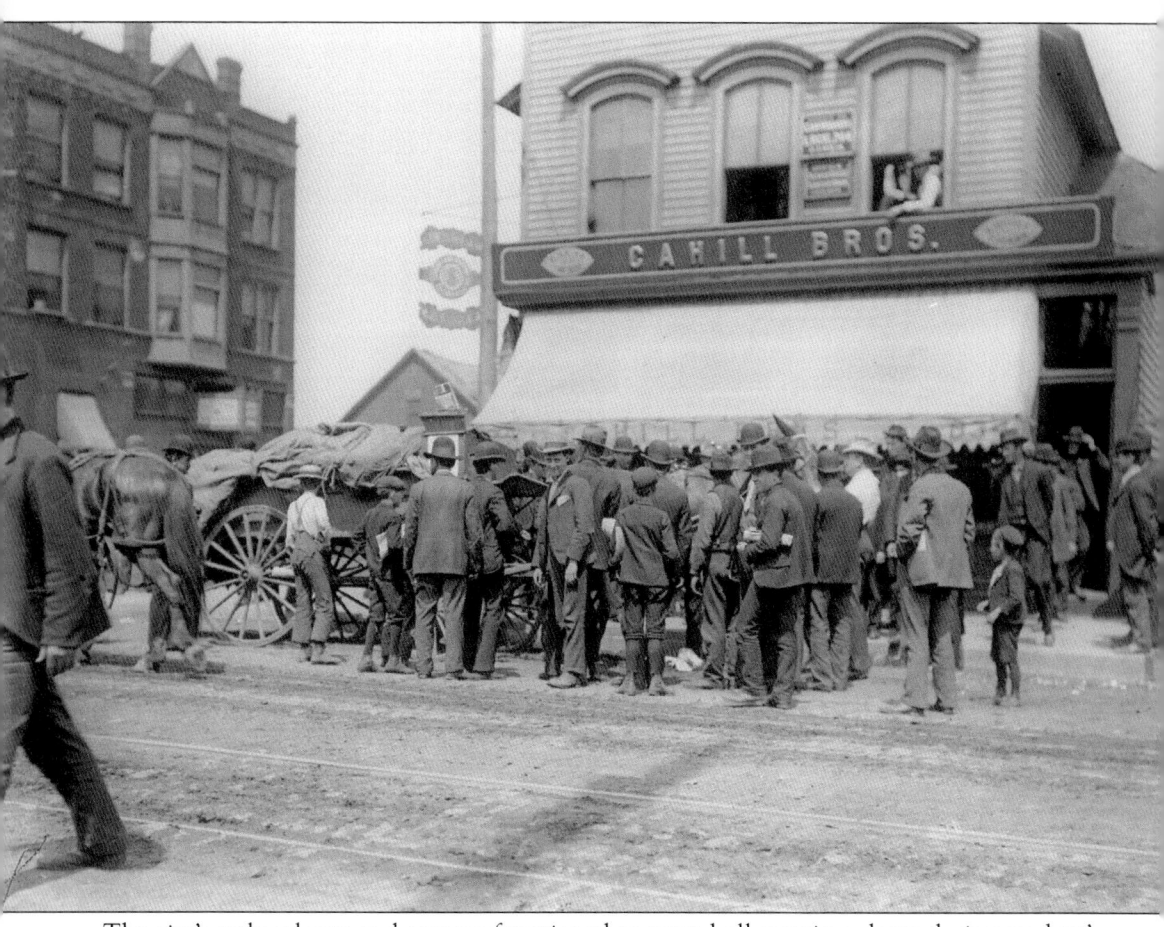

The city's early saloons and taverns functioned as town hall meeting places during workers' strikes, giving locked-out laborers a place to plot strategies and plan their next moves. (*Chicago Daily News*, Chicago History Museum, DN-0000882.)

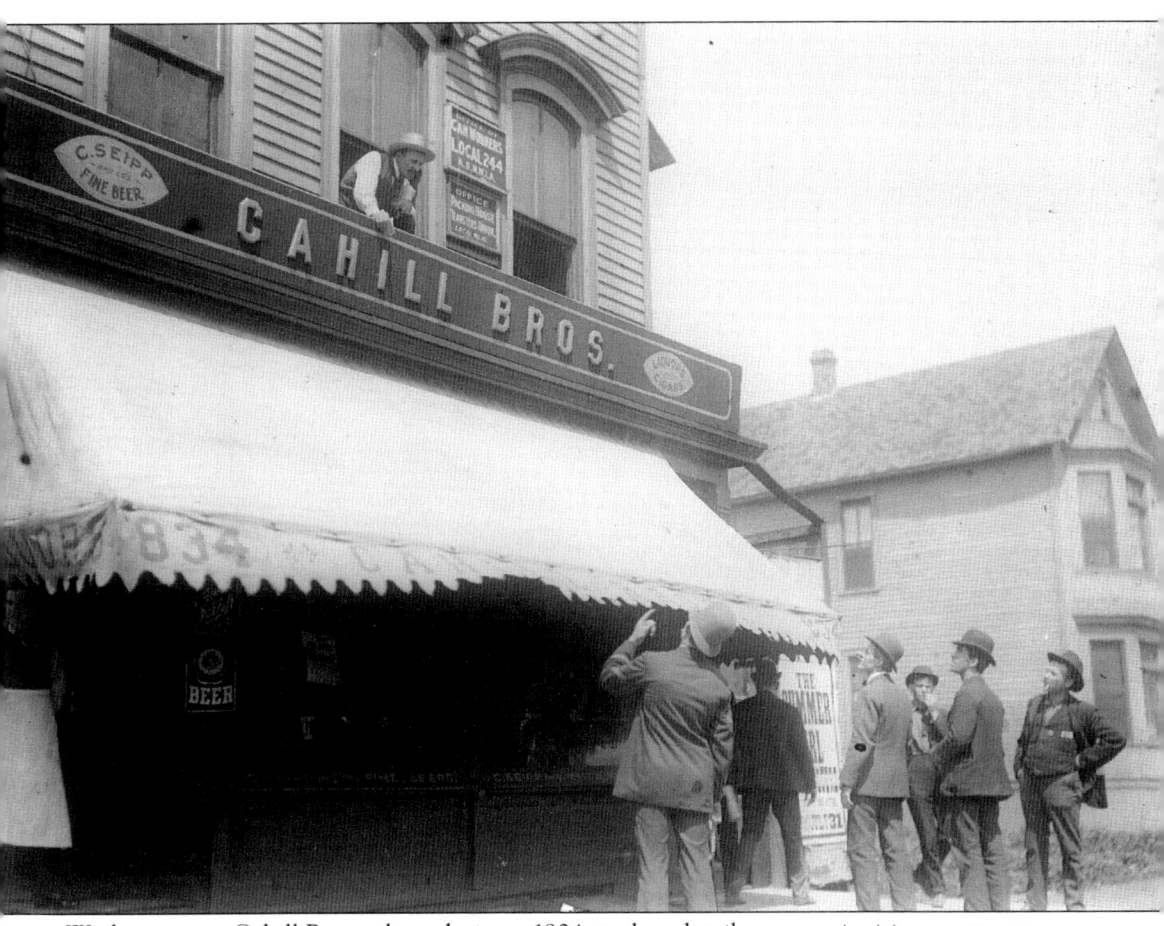
Workers met at Cahill Bros. saloon during a 1904 stockyard strike over unionizing meat cutters and butchers. (*Chicago Daily News*, Chicago History Museum, DN-0000923.)

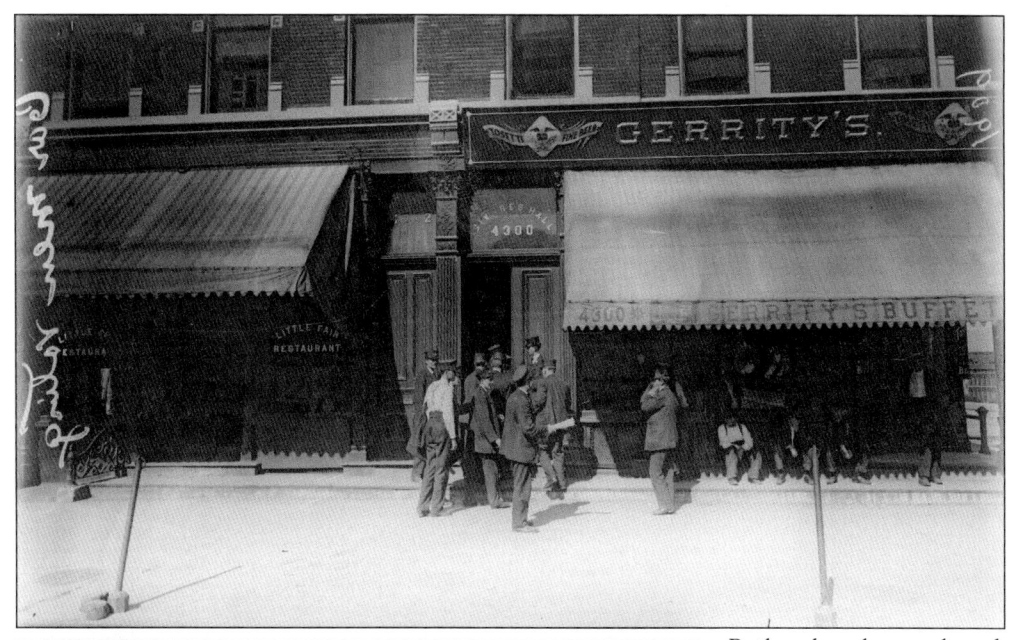

Railroad workers gathered at Gerrity's saloon to vote on a strike in 1909. (*Chicago Daily News*, Chicago History Museum, DN-0007585.)

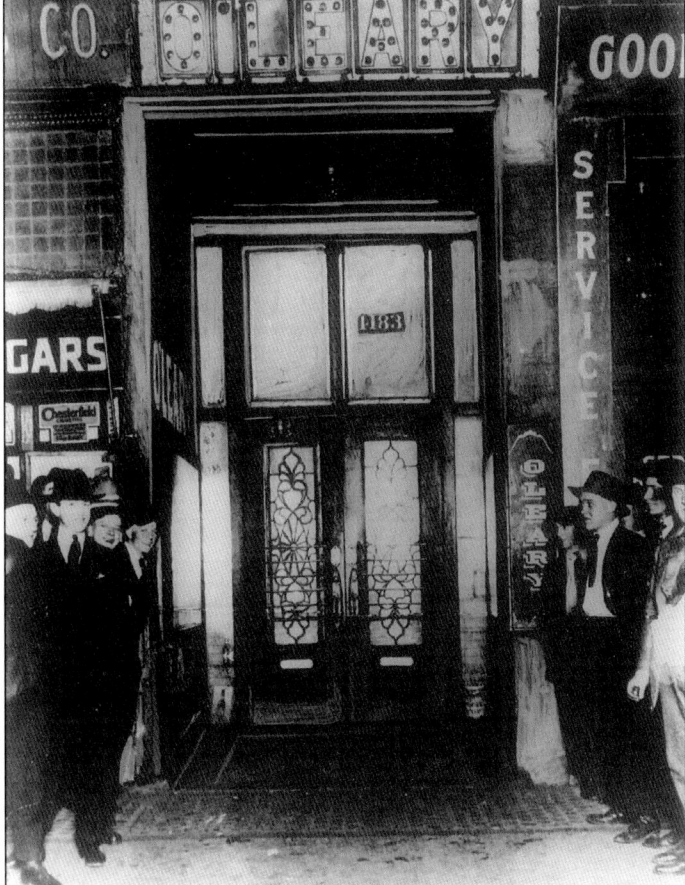

The heir to McDonald's gambling and liquor empire, "Big Jim" O'Leary, opened his saloon on Halsted Street in the 1890s. The son of Catherine O'Leary, in whose barn the Great Chicago Fire allegedly began, Big Jim was famous for betting on everything from sporting events to presidential contests. His establishment suffered not only from police raids, but also from bombings by rival gamblers, according to the family. (Neeson family.)

Creators of the city's First Ward political machine, "Bathhouse" John Coughlin and Michael "Hinky Dink" Kenna were elected to city council from the levee district in the South Loop in the late 1800s. Their centers of power were the saloons and gambling halls in the area, and they exploited those centers to coerce and control voting. A *New York Times* story from the 1896 elections asserts, "The 'levee' section of the First Ward provided its usual quota of brawls, with fists, rocks, and clubs as weapons, and whisky as the accessory in every case . . . the factions working for 'Bathhouse John' Coughlin, the present Alderman, and George H. Williams, his opponent, came in conflict with fists and revolvers. Numerous arrests were made." (Tom Boyle.)

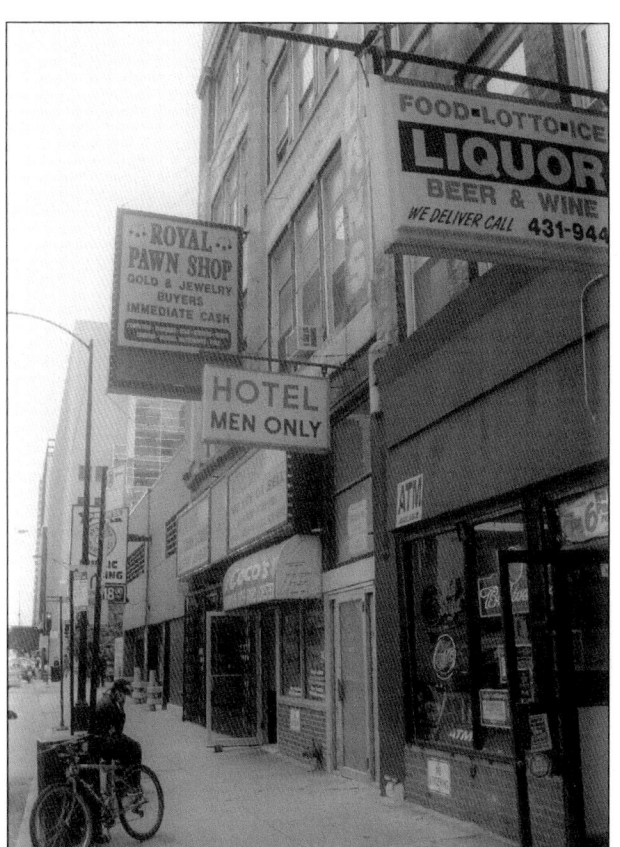

Kenna's tavern, the Workingman's Exchange, is long gone, replaced by a pawn shop, but the men-only hotel located above it still serves its intended purpose. (Authors' collection.)

P. J. O'Dea, an Irish immigrant from County Clare who opened the Notre Dame Inn on the city's west side in 1964, told a tale of being shaken down by a police commander looking to make extra protection money from Irish tavern owners. "I wouldn't pay them off," he remembered. "I was the only one who wouldn't." The corrupt policeman backed off quickly, O'Dea said, when O'Dea mentioned he happened to purchase insurance from a certain politically connected Irish family with the name of Daley. "They didn't like that very much," he said. (P. J. O'Dea.)

The city's annual St. Patrick's Day parade is as much a festival of politicking as it is of Irish heritage. Tavern owners' floats mingle freely with those of aspiring or successful pols, as shown by this Glascott's float from the 1960s. (Glascott family.)

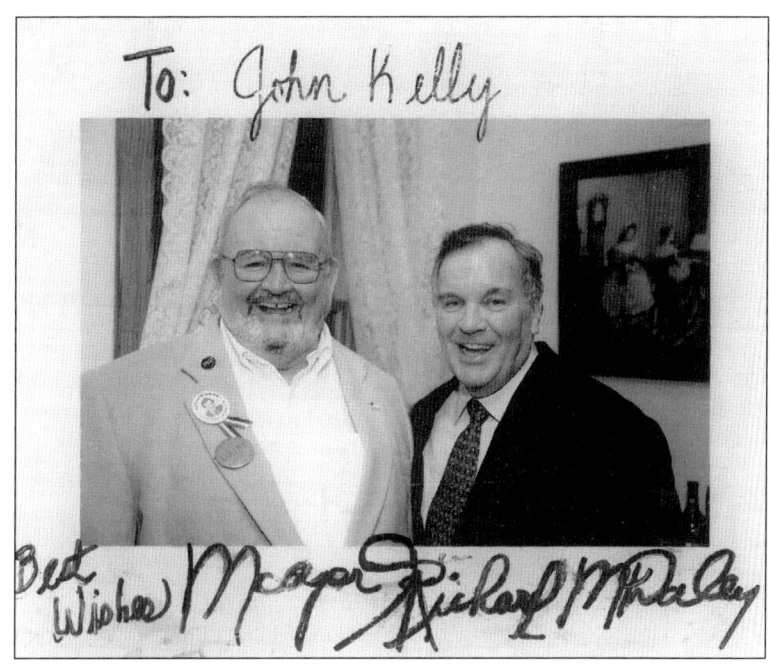

John Kelly, left, owner of Kelly's Tavern on the city's north side, stands beside Mayor Richard M. Daley. The mayor's presence looms large at Kelly's, where John Kelly says Daley's father used to stop by for a chat now and then. (John Kelly.)

Chicago's Irish pubs were also meccas for the city's journalists, Irish or not. Photographer Jack Lane recalled spending many an evening with Roger Ebert and Tom Wolfe at O'Rourke's, a bar on North Avenue, in the 1960s and 1970s. "Anything could happen there," Lane said. "The Algonquin Round Table was nothing compared to that place." Drawn to the company of the city's critics and scribes, visiting celebrities often clustered around Ebert, including, one night, Charlton Heston. "So this girl goes up to him and says, 'Mr. Heston, will you sign my bra?'" Lane remembered. "And he says sure, so she takes off her shirt and says, 'Whoops!' She wasn't wearing a bra. Every night was like that." (Jack Lane.)

Former Chicago mayor Jane Byrne (left), Irish merchant Maureen O'Looney, and Sen. Ted Kennedy are pictured in the Irish Village pub in the early 1980s. The Village hosted a number of political and musical gatherings over the years and was a mecca for visiting politicos. (Maureen O'Looney.)

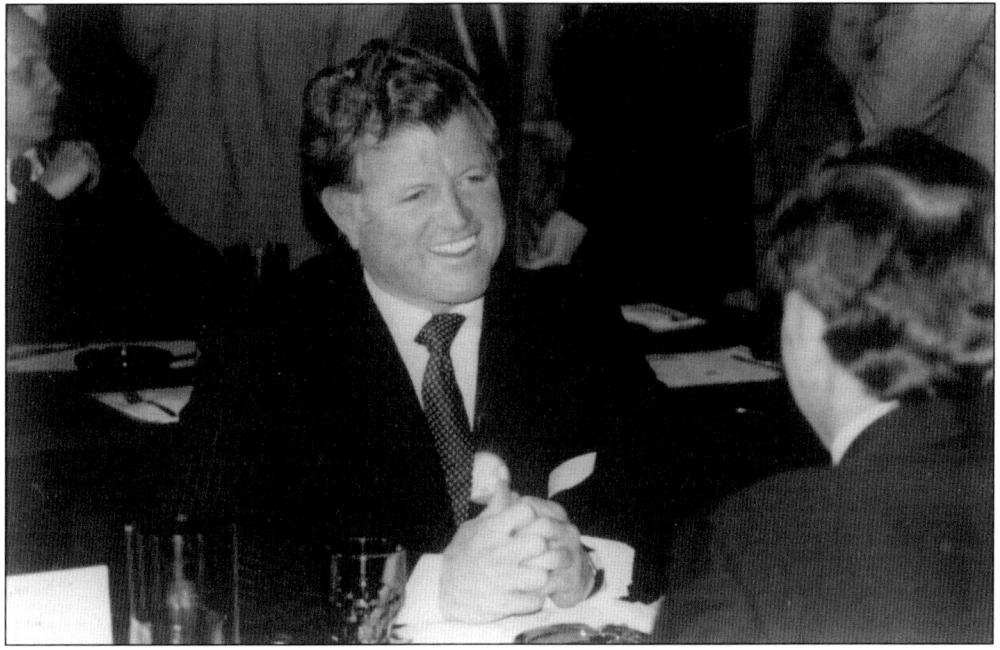

Ted Kennedy socializes at the Irish Village. (*Irish American News*.)

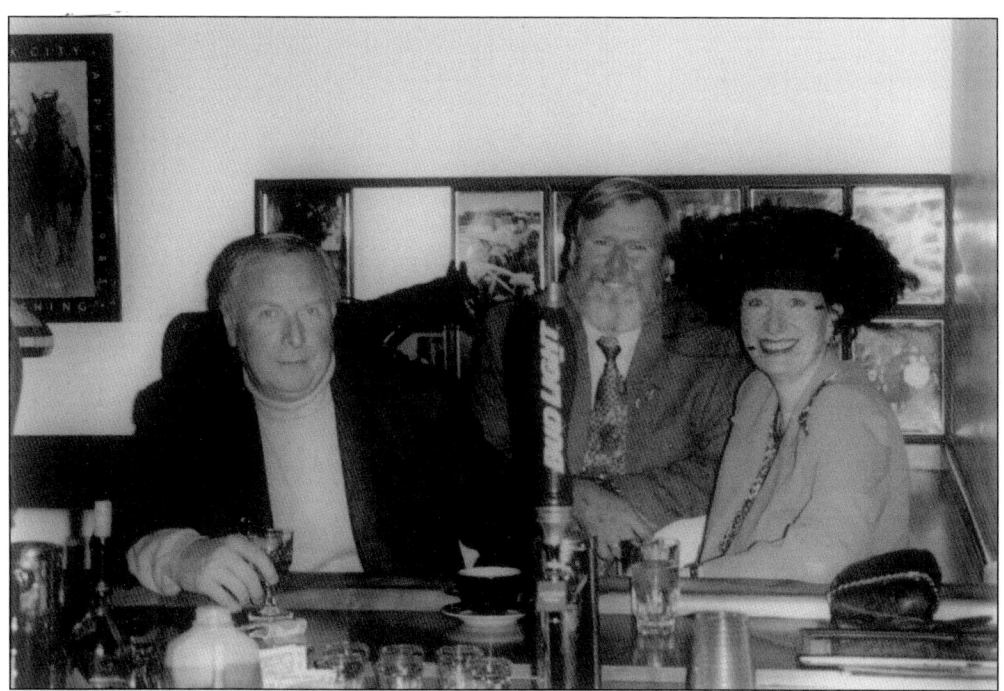

Judge Anne Burke sits in O'Brien's pub on Wells Street, another busy political meeting place. (*Irish American News*.)

Kitty O'Shea's in the Chicago Hilton and Towers hosted one of the largest political parties of the modern age, becoming a mecca for Barack Obama supporters before, during, and after the president-elect's victory speech in Grant Park in Chicago. (Shay Clarke.)

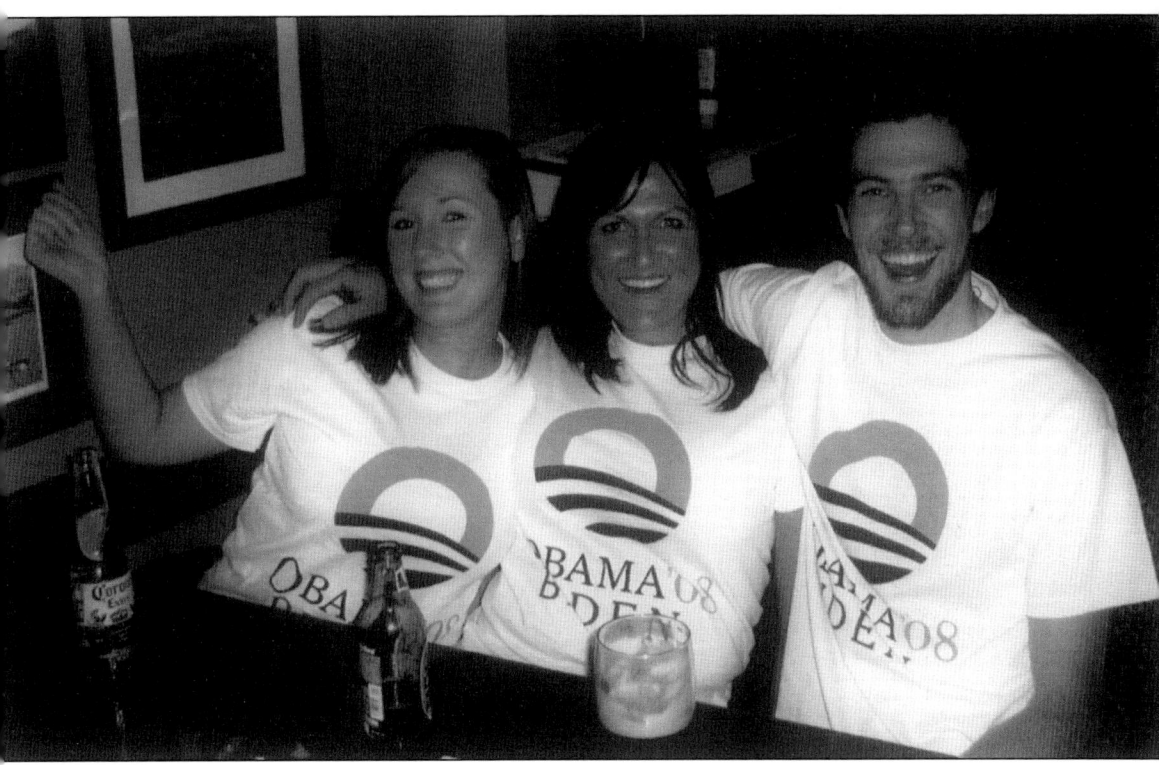

The crowd at Kitty's on election night in 2008 became so thick firefighters had to bar the doors, but happy partygoers inside were too busy celebrating to notice. (Shay Clarke.)

Chicago congressman Danny Davis and Irish entrepreneur Shay Clarke visited at Kitty O'Shea's on election night in 2008. (Shay Clarke.)

Three

Tales from Chicago's Historic Irish Pubs

One of the things that makes Emmit's Irish Pub, 485 North Milwaukee Avenue, quintessentially Irish is that it is owned and operated by two Chicago area firemen. What makes it historic is a colorful background that includes gangster lore and modern-day movie makers.

The firefighters in question are Ron Halvorsen and Kevin Doherty. These men are so Chicago they identify themselves by the Roman Catholic parish they attended as kids.

"I was from St. Ed's, he was from St. Pascal's, and we both attended St. Patrick's High School," Doherty said.

The two opened the spot, which sat vacant for eight years, in 1996.

"It went up for auction, we bought it, gutted it, and rehabbed it," Doherty said. "We did it ourselves. I think why moviemakers like it is because it doesn't look like a set."

The project took three years. Doherty noted that prior to sitting empty, Emmit's was known as O'Sullivan's in the 1980s. Former owner Mike Johnson and old patrons filled them in on the details of the pub's past.

Back in the Roaring Twenties, the site was the Italian Trust & Savings, which held reputed mob money in safety deposit boxes.

Doherty heard that back then the neighborhood's rough reputation was such that police infrequently patrolled it. And Johnson told them there was a vast tunnel system that ran from the bank to somewhere near the Field Museum.

Johnson opened O'Sullivan's Public House in 1981. Doherty said it was a place where judges, states attorneys, politicians, and police came to drink.

According to Emmit's Web site, in 1985, two none-too-bright guys tried to rob O'Sullivan's at gunpoint. It was a deadly error in planning. The bar also received a bit of notoriety in the O'Sullivan's era by hosting a dwarf-tossing contest. The story goes that Mayor Harold Washington called the place himself to put the kibosh on the promotion.

The firefighters named their pub after famous clown Emmett Kelly and Irish rebel Robert Emmet. As the neighborhood has improved, Emmit's has built a following that still includes attorneys and the occasional sports figure.

Over the last few decades—first as O'Sullivan's and now in its present incarnation as Emmit's—the spot has seen its share of film and TV crews.

"Before we owned it, they shot scenes for *Uncle Buck*, *Only the Lonely*, *Blink*, and *Backdraft* here," Doherty said.

During their tenure, Emmit's has been used in *Ocean's 11*, *Turk 182*, and one of Patrick Swayze's final projects, *The Beast*, Doherty said. On St. Patrick's Day 2008, a crew from CNN set up at the Chicago pub for shots that were included in the cable network's remotes from places celebrating the Celtic holiday the world over.

Emmit's has ties to the Chicago Irish community as well and one pipe band in particular. "The Shannon Rovers hang out here, too. Sometimes they'll play standing on top of the bar. And those are some big guys," Doherty said.

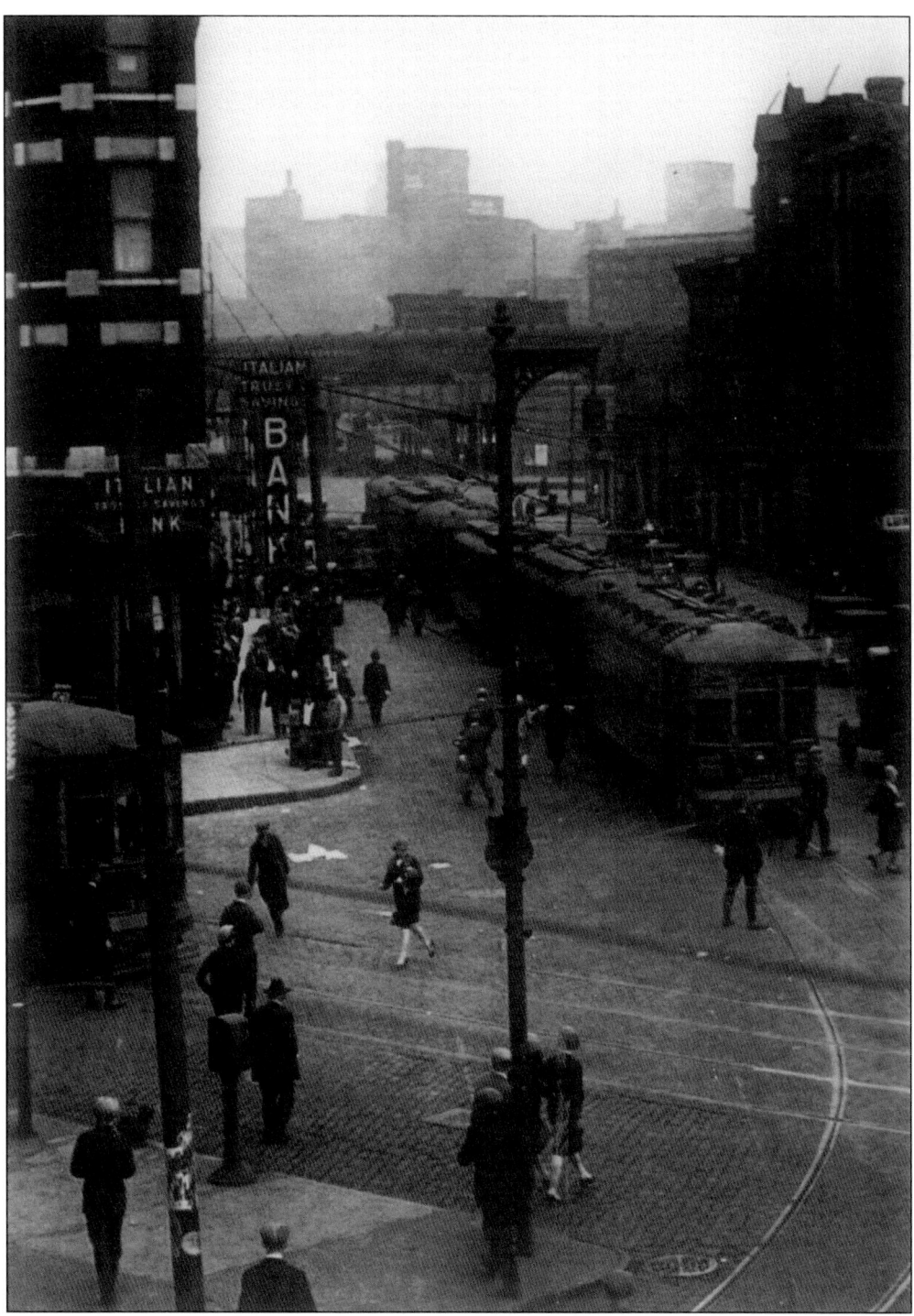
The intersection of Milwaukee and Grand, where Emmit's building can be seen under the sign "Italian Trust & Savings Bank," looked like this in the 1920s. (Emmit's.)

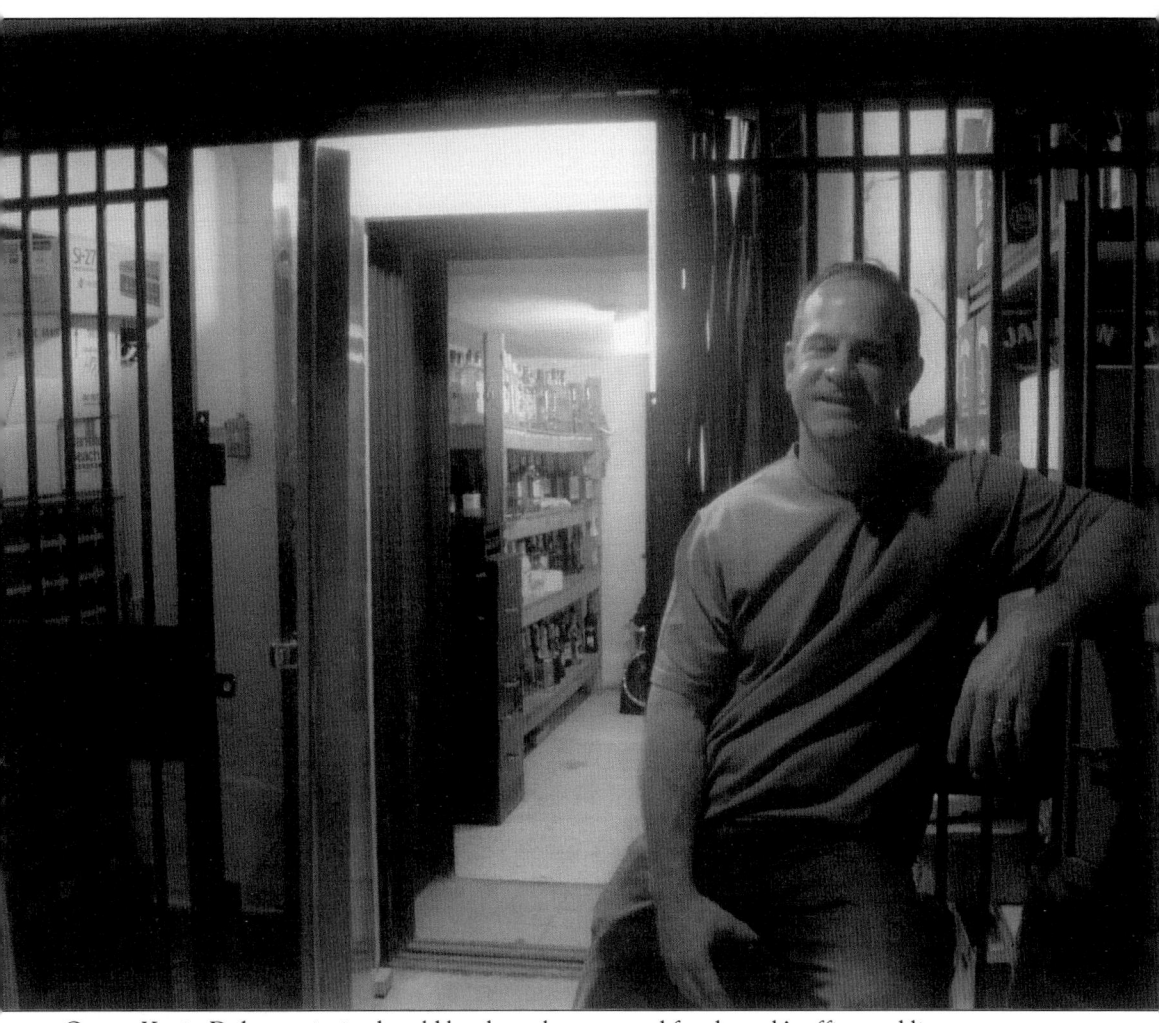

Owner Kevin Doherty sits in the old bank vault, now used for the pub's office and liquor storage. The office connects to a secret series of narrow, dark tunnels that reach out of the building and under the city's sidewalks. (Authors' collection.)

This is Emmit's as it looks today. (Authors' collection.)

The Shannon Rovers, founded by Tommie Ryan in his own pub, play inside Emmit's, standing on the bar. (Emmit's.)

The bar's customers are primarily young professionals on their way home from work in the Loop and young couples who live in the city. As these people move out into the suburbs, Halvorsen said, the bar's clientele changes every few years. (Emmit's.)

A server at Emmit's wears a shirt bearing the bar's slogan as the Rovers play in the background. (Emmit's.)

Alice Doherty (left) was born in the apartment above a small Bridgeport bar in 1896. In the front of the bar was a small cigar shop, and in the back was the family's living space. Today, that bar is in the hands of her grandchildren and great-grandchildren, but it still serves the neighborhood, just as it did when Alice was young. She married Mike Doherty in 1918. This is their wedding photo, taken shortly before he left to fight in World War I. (Shinnick family.)

When Prohibition ended, George Shinnick purchased the bar, then called the "Unique Club," and set about raising his children there. Donald, aged about four, can be seen behind the bar beside his father. (Shinnick family.)

Shinnick's had been a speakeasy during the years of the Volstead Act, surreptitiously serving alcohol supplied by Capone to customers who entered through a secret door connected to the apartment entrance on Union Avenue. That door has since been plastered over but can be seen in the far right of this photograph. (Shinnick family.)

Regular customers came in the form of baseball fans from nearby Comiskey Park (now from U.S. Cellular Field), workers from the factories, and downtown men returning home from the office. Shinnick's developed a fiercely loyal clientele, said Celine Flynn, granddaughter of Alice Doherty and George Shinnick. One man came in every night for nearly 40 years. "He'd come in in the afternoon, have three beers and a cigar, go home, have dinner, come back, have three more beers and go home again," she said. "Every night, that was his routine. This was like his living room." (Shinnick family.)

Growing up, Flynn said, the kids would come to the bar to see Grandpa Shinnick, who would always flip them a coin as a treat or serve them an ice cold soft drink in a glass bottle. "He was a very kind, generous man," she said. "He always had a smile for everybody in the neighborhood." (Shinnick family.)

Initially, as in many older pubs, women weren't allowed in the bar, but gradually they became accepted. The daughters of Alice Doherty, right, seen here with her mother, Nell Barlett, enjoyed spending time at the bar their whole lives. (Shinnick family.)

Before Flynn's father, George Shinnick Jr., left for World War II, he posed for photographs in his uniform outside the bar. (Shinnick family.)

George Shinnick Jr. (center) stands with sister Shirley (left) and friends outside the pub. The neighborhood sent most of its young men into the military during the war, and the bar was a place where people exchanged information about who had come home and who was still waiting to hear about their children. (Shinnick family.)

Upon his return from the war, George Shinnick Jr. (pictured here with three other neighborhood men who returned around the same time) went right back to work serving drinks. He and his wife, Celine Dougherty, formally took on the bar in 1966. (Shinnick family.)

Nadine (left), mother Celine, and daughter Celine Flynn all celebrated St. Patrick's Day with songs. Flynn remembered it as a wonderful place to grow up. "My mother worked hard, but she was always happy, and she made everybody else happy to be around her," she said. (Shinnick family.)

George Shinnick Jr. and Celine celebrated St. Patrick's Day with large crowds in the bar. Flynn said election nights were also full of excitement because of the bar's proximity to the local Democratic Party and Teamster headquarters. "The bars were closed until after the polls closed, but then everybody would pack in here to get the results from the precinct captains," she said. For years, pictures of the first Mayor Daley and the local aldermen hung over the bar. When Shinnick's recently repainted, Flynn said, customers were outraged because the picture of the mayor had been removed from the wall. It was replaced quickly. (Shinnick family.)

The Shinnicks' children grew up in the tavern and celebrated most of their momentous family milestones there, surrounded by the customers who became like family. (Shinnick family.)

Customers celebrated New Year's Eve, a busy night in the bar. Celine Flynn said her father often opened and closed the bar, in addition to working for the city, every day of the week. (Shinnick family.)

Alice and Mike Doherty are seen here outside the bar on their 50th anniversary in 1968, near the location of their original wedding photo. (Shinnick family.)

All nine Shinnick grandchildren—Tom, George III, Timmy, Nadine, Terry, Michael, Joanne, Kathy, and Celine—were on hand to celebrate the White Sox winning the World Series in 2005. The longtime Sox bar was a shower of champagne and elation, and all Celine Flynn could think was that her father and grandfather, lifelong Sox fans, would have loved to have been in their family pub that night. (Shinnick family.)

Outside Glascott's Groggery, 2158 North Halsted Street, on a warm Sunday afternoon, well-heeled fashionistas paraded with tiny dogs and huge purses, trailing clouds of perfume from one elegant boutique to another in the tony Lincoln Park neighborhood. Cell phones pressed to ears, they chattered about which upscale restaurant to visit for dinner and which club to hit afterward, fantasizing about fancy martinis and flavored shots. (Authors' collection.)

Inside the 73-year-old tavern, connected by a back hallway to a Greek restaurant, a white-haired fellow sat puzzling over a racing report and drinking a large glass of whiskey very slowly. The bar was dark and nearly silent; bartender Nick had shut off the White Sox game in despair over yet another loss. "They got a manager that can't handle a pitching staff," he lamented. "That's still no excuse for how bad they are." (Authors' collection.)

The Glascott family has held liquor licenses in the city of Chicago since the 1880s, when Patrick Glascott opened a bar on Ashland Avenue. Seen here supervising a wrestling match in the yard, the man had a wooden leg, and his sons would regularly steal it to "play pirate," said Bob Glascott, Patrick's grandson. "I'd ask my dad, 'What did he do to you when he found out?' And Dad would just laugh and say, 'What could he do? We had his leg! He couldn't catch us!'" (Glascott's.)

The current incarnation of the bar opened in 1937, when it was one of several Irish bars on the street. Bob Glascott's father Larry ran the tavern, raising seven sons—including local football star Edward, seen here third from the left—and one daughter from behind the long wooden counter. "It was a shot and a beer kind of place," Bob Glascott said. "He'd open at 10 a.m. and have them three deep at the bar, and then they'd go off to work. When TVs came in, he was one of the first in the neighborhood to have a TV so everybody just came over and watched the *Friday Night Fights* in the bar. The whole family would be here." (Glascott's.)

Seen here are Edward, John, James, Timothy, Lawrence Jr., Dennis, Robert, and Mary Ann Glascott, with their parents. The bar provided a stage for the children to watch their dad work, and they admired the way he policed the neighborhood, sending those too drunk to drive home with friends or in taxis, giving those who were at loose ends a place to connect. "A lot of these guys were tradesmen and they lived in tiny apartments, no windows, so the tavern became their living room," Bob Glascott said. (Glascott's.)

The day after Prohibition ended, Frank Kelly closed the Sugar Bowl candy store in Lincoln Park, beneath the elevated tracks on Webster Street, and opened up The L Tavern in its place. A dark wooden bar that echoes when trains rattle past, Kelly's new venture became a family tradition as well as the neighborhood hangout. "The tavern was the country club of its neighbourhood," said John Kelly, Frank's son and the bar's current owner. "Taverns sponsored the sports teams, they hosted the picnics, they held the wakes and the birthday parties and everything else." (Kelly's.)

Frank Kelly's wife was instrumental in starting a garden walk in the area, headquartered out of the bar (seen here in the late 1930s). The Kellys hail from Roscommon, in the west of Ireland. "When we came here, the neighborhood was primarily German and Irish," John Kelly said. "Then for a while it was more Spanish, and now it's upscale young professionals, a lot of whom work at DePaul University." (Kelly's.)

Its proximity to DePaul made Kelly's a natural sports fan bar. (Kelly's.)

Here fans celebrated the DePaul University basketball team making the final four in 1979, and coaches and their staffs were frequent visitors to the tavern. "In 1985 when the Bears won the Super Bowl, we ran Ditka for mayor," John Kelly remembered. "We made up banners and buttons and had a lot of fun with it. That's the kind of place we have. We have a lot of fun." (Kelly's.)

This is Kelly's today, still beneath the L tracks, though a train no longer stops here. (Authors' collection.)

The first member of the Chicago Healy family to emigrate from Ireland opened a pub in Baltimore. A native of Foxford, County Mayo, Patrick J. Healy (center, in vest) opened what is now Patrick's on Pratt in 1863. He brought the rest of his family to the United States via the tavern, including two nephews who opened bars on Madison Street in Chicago. (Healy family.)

"Back then you'd get off the boat or the train, and the first thing you'd do is find a tavern," said Terry Healy, Patrick's great-nephew and one of the owners of what is now Healy's Westside in Forest Park. "You could get a meal, get a drink, get a job, find out where to stay, and learn everything you needed to know about America in the tavern." (Healy family.)

Mike Healy came to the United States in 1922 and opened Healy's at the corner of Madison Street and Kostner Avenue in 1954, where Fancy's Inn and numerous other establishments in the popular west side Irish community were also located. His sons Terry and Dick tended bar and recalled some of his most outrageous customers, including one called "Terrible Tempered Tommy" and another known as "Calamity O'Shea." "He had a face like he'd been hit with a coal shovel," Dick Healy said. "It was a calamity to have him in your bar." The bar was "full service," Terry Healy said. "When a guy came in with a sore tooth once and was complaining about it, this mechanic sitting there said, 'Hold on a minute.' He went out to his truck, got his pliers, and pulled the guy's tooth in the back room of the bar. No matter what you needed, you could find it at your local." (Chicago History Museum ICHi62147.)

Today Healy's holds down the corner of Madison Street and Circle Avenue in the near west suburb of Forest Park, having moved from the city in the late 1960s. The bar became one of the staging grounds for a notorious prank when, in 1963, a group of local coaches tried to get free tickets to the NCAA basketball championships by inventing a fake university. They named one another chancellor, athletic director, and facilities manager, applied to the NCAA, and were accepted, giving them all free tourney tickets for a year. McGuire University (so named for the former tavern where the plot was hatched) was discovered, exposed, and banned, though coaches and friends continue to make the trip to the tournament each year—now on their own dimes. (Authors' collection.)

Healy's Westside

est. 1954
Forest Park

7321 West madison Street
Forest Park, IL 60130

708-366-HARP

Visit Our Other Locations!

Cocina Lobos
7321 Madison St. in Forest Park

Art's Tavern
4510 Buttterfield Rd. in Hillside

www.healyswestside.com

Healy's current customers are a tame mix of the working-class neighbors and city kids heading west, and nobody pulls any teeth, as that would violate health regulations. Despite the lack of unlicensed dentistry, the bar remains lively and loud. "I hope we're still here in 2054 celebrating our 100th anniversary," Terry Healy said. "I hope it remains a family tradition." (Healy family.)

An Irish place known for its pizza has been a south side tradition for more than 40 years. And it had ties to Al Capone. According to Tom Fox, back in 1964, his father, Tom, worked at a deli that would trade meat for pizza with a local joint. That parlor was owned by one of Capone's sisters, Fox said, "and she made my dad an offer he couldn't refuse," he joked. That was the Beverly Pizza House, 9956 South Western Avenue, from which the family grew a business that, like the Irish in Chicago, spread across the south suburbs. (Tom Fox.)

By 1971, Tom and Therese Fox had opened their second spot at 9240 South Cicero Avenue in Oak Lawn. (Tom Fox.)

54

"My mother was very much into her Irish heritage," Tom Fox said. So much so that she had the idea to combine an Italian kitchen with a Chicago Irish atmosphere. "After that, the place really took off," Tom said. Here an employee decorates a young customer for St. Patrick's Day. (Tom Fox.)

The success of the Oak Lawn location, seen here, led to the opening of another Fox's in 1973 at 9655 West 143rd Street, Orland Park, which Tom Fox said is the oldest restaurant in that far south suburb. Tom used to do his homework in the restaurant. He has been working in his late parents' establishments since he was 11 and bussing tables. "I gave it a try, and it stuck," he said. (Tom Fox.)

55

Fox's staff, seen here, are a close-knit bunch. Tom Fox's sisters Patty and Kelly have also been involved with the business. His brother opened Fox's on Wolf, 11247 West 187th Street, Mokena, in 1998. The family also runs Tailgator's, 9240 South Cicero Avenue, Oak Lawn. And they opened a new Fox's in Plainfield in 2010. No cookie-cutter chain, each restaurant has its own decor. (Tom Fox.)

Tom and his clan are proud that in 1993 the Illinois Restaurant Association recognized Fox's for their longevity and excellence, an honor he says reflects well on his parents' legacy. (Tom Fox.)

"Our success is due to the core values of our parents. They were hard working, paid a lot of attention to detail, and above all were about their family," Tom said. "My mother enjoyed people and getting to know her customers." (Tom Fox.)

Butch McGuire's may not be your traditional Irish pub, but this family-owned Division Street establishment holds more than its fair share of local tavern lore. Plus, how much more Chicago can you get than being named after an Irish guy called Butch? (Butch McGuire's.)

Robert Emmett "Butch" McGuire (left), who passed away in 2006, grew up in the city's Beverly neighborhood and was an architect living in Old Town when he got the idea to open his own place, said Bobby McGuire, Butch's son. (Butch McGuire's.)

McGuire and pals had been throwing parties for stewardesses at McGuire's digs, charging a dollar or two at the door. The parties became so popular that the light bulb went off about opening a bar. "He got a loan from my grandmother. She made him promise that if she gave him the money, he would keep the business in the family," Bobby recalled. (Butch McGuire's.)

That he did, opening his establishment in June 1961 and ushering in an era when Butch's became synonymous with Chicago nightlife and the rise of the singles bar. Back then, the Rush and Division Streets corridor was seedier than it is today, recalled Bobby, who was born in 1965. In fact, McGuire's opened in a spot that held something called Bobby Ferrell's Duchess Show Lounge, Bobby said. (Butch McGuire's.)

One of the things Butch McGuire did was make women feel safe at his place. "He catered to women," Bobby said. "He put their safety first and would make sure they would have rides to and from the bar." (Butch McGuire's.)

59

That attracted male customers, and the joint was jumping pretty much from the get-go. Soon the place was attracting local politicians; people from the exchanges and the advertising world; Hugh Hefner, who lived around the corner; and even John Wayne, who would visit during stays at the Ambassador (East), Bobby said. (Butch McGuire's.)

Bobby McGuire recalled that his father was a bit of an innovator too. He claims his father's bar design, with its bar-height tables, served as a prototype for chains like TGIFriday's. Butch McGuire also hired female bartenders and managers. And he is credited with inventing one of the ultimate drinks of the 1970s, the Harvey Wallbanger. (Butch McGuire's.)

By 1970, McGuire (right), pictured here with Harry Caray, was so successful he opened a second spot in Mount Prospect, "in a big old house with a carriage house on 4 acres of land, so there was plenty of parking," Bobby said. (Butch McGuire's.)

By the time he was 10, Bobby was doing menial jobs around the Chicago location, and at 12 he collected his first paycheck. Seen here are Butch (as Santa), Terrance, Mary Jo, Bobby, and Lauretta McGuire in 1975. (Butch McGuire's.)

"My dad asked me what I thought I was worth, and we settled on $3 a day," Bobby said. The family lived up the block on Dearborn Street, and Bobby "thought everyone lived the same type of life I did." Here Butch McGuire is pictured with two patrons. (Butch McGuire's.)

As the disco era waned, and by the start of the 1980s, Bobby said Butch McGuire's was feeling competition from what his dad called "the health club revolution." In particular, the bar was facing challenges from the likes of the East Bank Club, where people could exercise, then dine and drink, putting back on the calories they had just burned. (Butch McGuire's.)

With the election of the second Mayor Daley, the Rush and Division area went through a Renaissance. (Butch McGuire's.)

"The neighborhood changed. Nicer restaurants and hotels came in, and the city changed how it looks after the neighborhood, treating it as an entertainment district," Bobby said. The city's change to having its St. Patrick's Day parade on the Saturday before (or of) the holiday also has helped Butch McGuire's, Bobby said. (Butch McGuire's.)

OFFICE OF THE MAYOR
CITY OF CHICAGO

May 13, 1966

Mr. Robert McGuire
20 W. Division St.
Chicago, Illinois

Dear Mr. McGuire:

I would like to express my personal appreciation for your participation in Chicago's 1966 St. Patrick's Day Parade.

The splendid support you gave the parade committee helped make it one of the finest parades in the city's history.

Again, thank you for your cooperation.

With best wishes,

Richard J. Daley
Mayor

"When the parade was on the actual day, we were packed. By 8 a.m. there was a line out the door and people were here until 2 or 3 a.m.," Bobby said. (Butch McGuire's.)

With the current set-up, "We get at least two days out of it and a good brunch on the Sunday, too," Bobby said. (Butch McGuire's.)

Butch McGuire's parents came to Chicago from Aberdeen, South Dakota. But Butch, pictured here with wife Mary Jo, was very proud of his Irish roots, frequently visited Ireland, and started the custom of hiring Irish students as workers during summer, Bobby said. (Butch McGuire's.)

Over the years, while always keeping a foot in the door at his dad's place, Bobby ran Sedgwick's for its first five years and had stints with JAM Productions and Shoreline Sightseeing Cruises before returning to manage the family business. (Butch McGuire's.)

"I always figured this is what I would do," Bobby McGuire said. Pictured here are McGuire's employees from the late 1960s. (Butch McGuire's.)

Cork and Kerry manager Devra Brenn is a little afraid of "The Pig." In the basement of the south side tavern is a remnant of the bad old days of smuggling booze and dodging federal agents—a small, dark, damp room that predates not only the current Cork and Kerry but Frank and Sons, the bar that preceded it. The staff calls it The Pig. "Back then I hope they took better care of it, but now it's just a gross basement," she said with a shudder. (Chad Weiler.)

This well-known establishment in the Beverly community isn't the only area tavern with a claim to history, but it is best known for being a gathering place for the south side after Sox games, during the once-annual South Side Irish Parade, and for some older customers, every night after work. "Some of my regulars, I've known for 18 years," Brenn said. "I go to their family parties. I get invited to their weddings. I'm not just a bartender, I'm their bartender, and I've become a family friend." (Chad Weiler.)

The building that houses Cork and Kerry was built in 1930, and in 1988 Chad and Scott Weiler bought it and opened the bar. Weiler had worked for Butch McGuire and wanted a place of his own. "When we started out there were a lot more neighborhood taps than there are now," Weiler said. "The industry changed, and the corner tavern wasn't the norm anymore." (Chad Weiler.)

The Weilers instituted some traditions, like crazy Christmas decorating, that endure to this day and make the inside of the bar light up like a carnival arcade in December. (Chad Weiler.)

The bar survived a fire in 1999 and reopened a year later, its interior restored to the glory days when The Pig was a necessity instead of a curiosity. And though walking inside might feel like walking into a time machine, Brenn said the clientele remains a club unto itself. "Walking in, you're never drinking alone for too long," she said. "You'll sit down, and see someone you know. It's the kind of place where you're guaranteed to find someone to share your cocktail with you." (Chad Weiler.)

Four

The Pub as Immigrant Experience

Musician Joe Cullen recently took a trip back to Murray's in Chicago's Jefferson Park neighborhood, a small bar that he says played a big role in the wave of interest in traditional Irish music that rolled across the United States in the 1990s.

From the outside, but for the name, you might not think there was anything Irish about the place. Like a good many taverns in Chicago, there is an Old Style beer sign in the front of the room, which is not any bigger than the basement of a large suburban home.

Irish immigrant Mike Murray opened the tavern in 1953, and his handsome photograph still hangs behind the bar.

"When we opened here, this was like being out in the country," said Murray's widow, Edna, who also works as a realtor and who still operates the bar.

Edna says Murray's was one of the first places in Chicago that offered Guinness on tap. But Murray's biggest contribution to local Celtic lore comes from the Sunday jam sessions held there back in the late 1980s.

"It got so busy, they would let one person in when another left," Cullen said. "There were five bartenders working, and before the doors would open, they would line up the pint glasses and begin the pouring. They went through more Guinness here than anywhere at the time."

The Irish pub has served as the first stop for many a newcomer to the United States. It was a place he could find not just a drink, but a lead on a job, an apartment for rent, and a fraternal community not unlike that which he had left behind. Taverns were their banks, their employment agencies, their real estate brokers, but most of all, they were their first footholds in their new world.

Cullen explained that after college, with the economy back in Ireland not the best, he came to Chicago where some friends had settled. Murray's became a hangout for musicians, including Cullen, in no small part because of Edna's kindness.

"Every Thanksgiving Mrs. Murray would cook two turkeys and make sandwiches for those of us from Ireland," Cullen said. "We had no houses to go to, and she looked after each and every one of us."

Edna Murray stands beside her husband's portrait behind the bar in the pub he opened, which became a home away from home for so many. (Photograph by Kyle Bursaw.)

Early Irish immigrants settled where they worked, and so Irish taverns were located near the steel mills and dockyards that made heavy use of immigrant labor, like 91st Street and Commercial Avenue on the city's southeast side. (Southeast Chicago Historical Society.)

70

The early Irish immigrant persona was cemented in the American imagination by Finley Peter Dunne, whose comic tales of tavern owner Mr. Dooley began appearing in the *Chicago Post* in the 1880s. Dunne's characters spoke in thick Irish brogues and commented on the politics of the day, creating the image of the Irish tavern as a haven for political discussion, according to Chicago historian Tim Samuelson. (Tim Samuelson.)

Dunne first called his Irish barkeep Colonel McNeary, modeled after real-life Dearborn Street saloon owner Jim McGarry. When Dunne's pieces became popular, McGarry became offended by the notion he was being cast as a stereotypical Irish buffoon and Dunne changed the name from McNeary to Mr. Dooley. (Tim Samuelson.)

Dunne's characters were known for their pithy political aphorisms, such as "politics ain't beanbag" and "an appeal is when you ask one court to show contempt for another court." (Tim Samuelson.)

Dunne's work became so famous he attracted Pres. Theodore Roosevelt as a fan, and the president wrote to Dunne to tell him he admired Mr. Dooley's frank take on current events. (Tim Samuelson.)

Dunne himself was a devotee of the newspapermen's favored tavern, a place owned by Henry Kosters that he and his friends used for meetings of their "Whitechapel Club." This private society of Irish writers offered "wit and good fellowship" to its members as their main qualifications for entry, according to the publication *American Journalism*. Dunne himself moved to New York to further his career, like many a Chicago artist. (Tim Samuelson.)

Doris Neeson's grandmother, Bridget Frances Guinea, came to the United States from Limerick and opened a saloon at 4113 South Ashland Street with her then-husband, George Bowers, at the turn of the 20th century. It was his name on the sign outside, but she did the majority of the work behind the bar. "She was a strong lady. She had to be," Neeson said. "She was raising children and running the place herself." (Neeson family.)

When George Bowers died and Bridget Bowers remarried, her new husband, Jack Kennedy, put his name up over the saloon doors in 1906. This photograph shows her children—Josephine, Irene, and George Bowers (from left to right)—in July 1908, along with Jack Kennedy, who is holding a cigarette. Josephine was Doris Neeson's mother. (Neeson family.)

The saloon catered to the Irish working class in the area, serving women in a separate area in the back and providing a buffet lunch, Neeson recalled. "It was mostly stockyard workers," she said. "In those days you would stop at the tavern to pick up some beer and take it home." (Neeson family.)

Jack Kennedy (center, with cigarette) held the same pose years later as he had in front of the pub. (Neeson family.)

Bill King's parents emigrated from Ireland in the 1920s and opened a pub, the Panel Inn, on 75th Street in the city's South Shore community. It was primarily a place for his father and his friends to socialize, King said. (Bill King.)

"People didn't go out and drink really heavily," Bill King said. "The pub was the place for people to meet in Ireland, and people here don't always understand that." (Bill King.)

With early Irish immigrants having laid the foundation, later waves of immigration brought wealthier and better-educated Irish to American shores in the 1950s. They gravitated toward places that were more overtly Irish-identified, like Johnny Glavin's Clover Bar. (Authors' collection.)

The Harding Hotel on Clark Street offered the Irish-themed Erin Room, a dining room with shamrocks on the tables. (Authors' collection.)

O'Connell's looked more like an upscale restaurant than one of the late-1800s watering holes seen earlier. The building was designed by Alschular and Friedman. (Chicago History Museum HB-06465-F.)

Dugan's Cocktail Room was located in the 400 block of South State Street, as seen in this 1952 photograph. (Chicago History Museum ICHi-62140.)

This image from 1952 shows Flaherty's Tap Room on the 30 block of South Clark Street. (Chicago History Museum ICHi-27889.)

Irish pubs would cluster together, as seen in this photograph, and the competition encouraged rather than discouraged business. (Chicago History Museum ICHi-62144.)

Maureen O'Looney (left), 88, has a bar in her basement. But don't let that give you the wrong idea. She doesn't even drink. She's a Pioneer, which means she made a promise at her Catholic confirmation in Ireland that she would never, ever have any booze. But she knows that bars are about more than just downing a few pints. In fact, as a young woman, after Mass, she would head to Healy's or the Shamrock to play darts or pitch pennies. (*Irish American News*.)

O'Looney, pictured here in the Irish Village with actor Chuck Connors, came to Chicago in 1953 to visit an aunt. What was supposed to be a three-week vacation turned into a permanent move. "I liked to roam at home," O'Looney said. She took the *Queen Elizabeth* from Southampton to New York and wound up working for United Airlines out of Chicago's Midway Airport. She brought camogie, the distaff version of hurling, along with her from Ireland and met her husband, who played hurling himself, on the fields in Chicago. (Maureen O'Looney.)

Shortly after their marriage, United moved to the new, big airport on the northwest side, which seemed a world away from O'Looney's south side neighborhood. As a new wife, she was supposed to stay at home. That bored her, so in time for Christmas 1969, she opened her Shamrock Irish Imports on Laramie Avenue. Her store and her family became fixtures in Chicago's Irish American community. (*Irish American News*.)

P. J. O'Dea's Notre Dame Inn changed its name to O'Dea's in the decade P. J. owned it, as his own fame (he is a noted Gaelic football player) eclipsed that of the original bar. O'Dea liked the social aspects of owning a tavern, but just as many times he found them frustrating. "Guys would ask me to pick up the phone when their wives were calling the bar, and I'd always refuse," he said. "I told 'em 'I'm not gonna lie for you. Go on home.' " (P. J. O'Dea.)

O'Dea sold the bar in 1974, the expenses and rigor of the tavern business having worn him out. Here he sits with an award marking his induction into the Chicago Irish Hall of Fame. (P. J. O'Dea.)

One frequent refrain heard from tavern owners is that the pub was the Facebook of its day, providing a meeting place for groups such as the Young People's Irish American Club (YPIAC). (Irish American Heritage Center.)

YPIAC was a social as well as a networking group for those who had recently arrived both in Chicago and in the United States. (Irish American Heritage Center.)

YPIAC members are seen here at Sheehy's in the 1950s. (Irish American Heritage Center.)

Five

Music and the Pub

Margaret, Peter, Eamonn, and little sister Mary Brady arrived in Chicago in 1970 to play in a series of concerts that were to help raise the awareness of quotas on immigration for Irish and Germans to the United States. Known at the time as The Ormonde Folk Group, they played at several civic gatherings, including luncheons for Mayor Richard J. Daley.

One day, after one of those events, their equipment was stolen from a car parked in the west Loop. Since they were to play again for the mayor two days later, they contacted city hall to inform them of their predicament. They were summoned to the city hall press room, and their story became news.

WGN radio personality Wally Phillips picked up the saga and started a fund to replace the stolen instruments. A couple of mornings later, a call came from Phillips to the northwest side home of the Gillespie family, where the group was staying. He said he had received a call from city hall directing him to give the donated money to the Neediest Children's Fund; the mayor would take care of the group.

Peter and Eamonn still play the Martin guitars and Gibson banjo they received at that time.

The band—which once performed as the Brady Bunch before settling on Brogue—returned home to Kilkenny, Ireland, but headed back stateside to Nashville in 1973 to record a second album. That led to their becoming the house band at a bar there owned by fellow Irishman Shay Healy. After that bar burned down, the quartet moved to Chicago and set up a place of its own in 1977.

That establishment, the Kilkenny Castle Inn, at 3808 North Central Avenue on the northwest side, fast became a hub in Chicago's blossoming folk music scene.

"The music was all amazing, and we picked a spot in the middle of it all," Peter Brady said.

An Irish pub would not be an Irish pub without music. Whether a full band of traditional instruments or a small gathering consisting solely of voices, the music of the old country animates places in the new and provides a feeling of home.

The Larkin and Moran Brothers play all over the city, including at the legendary 6511 Club in Chicago's Marquette Park community and at Costello's Harp and Shamrock. The Kerry Piper (below) has also hosted the Larkins on several occasions. (Dan Larkin.)

Larkin described Ballydoyle Pub (pictured above and below) in suburban Downers Grove as "the best pub to play in from a band point of view." At Cullen's Pub "we played largely to Irish immigrants who were mainly tradesmen on Sunday nights," Joe Larkin said. "It was a scene out of *The Blues Brothers* where fights would often break out mid song and resolve themselves before the song ended. There was always a patron who felt he was a good singer and would insist on taking over. Mostly, though, people listened and thought about home." (Dan Larkin.)

"We still play the Kerry Piper three or four times a year with our March show being a big tradition," Larkin said. "In late 1998 we had the pleasure to share the stage with Bobby Clancy of the Clancy Brothers and his son, a young Finbarr Clancy, who currently is with the group The High Kings." (Dan Larkin.)

The Larkin and Moran Brothers also have memories of long-gone musical outposts. "The one thing I do know after 14 years is that many pubs just don't make it," Joe Larkin said. "Places like Reilly's Daughter, Joe Bailly's, Gunther Murphy's, and the (Schaumburg) Curragh are long closed but places we have played."

"We have also written some songs about our experiences in pubs, specifically a couple of fights the band got into," Larkin said. (Dan Larkin.)

Beginning in the late 1940s, south side Irish dance halls like McEnery Hall and Hanley's House of Happiness hosted nights of dancing and singing, as well as Irish-themed radio shows broadcast from inside. (Irish American Heritage Center.)

Fiddler Liz Carroll fondly recalled the whole family making visits to the halls. She later memorialized Hanley's, located at 79th and Halsted Streets, in a song of her own. (*Irish American News*.)

McEnery's can be seen from the street. "What I mostly remember is coming home those nights," Carroll said. "My father would be driving, and my mom was in the backseat with me. I had my head in her lap and she was singing a song we'd just heard. Those places gave me nothing but good memories." (Chicago History Museum, Ichi-62145.)

Bowen's Irish Orchestra featured Dennis Flynn Sr. (seated, left) and Dennis Flynn Jr. (seated, right). The band played taverns all over the city's south side, said Maureen Gillow, daughter of Dennis Flynn Jr. "I think for him, mainly, it was a way to spend time together as a family doing something meaningful," she said. "He had great memories of playing, but they were great because his father was there." (Maureen Gillow.)

The O'Leary Fife and Drum Corps, seen here in 1904, played at festivals and celebrations in the city, spreading the family name far and wide and associating it with more than just the establishment they owned. (Neeson family.)

The Shannon Rovers pipe band got its start in Tommie Ryan's west side Irish pub in 1926. Seen here in a recent incarnation, the Rovers play inside Emmit's Pub, standing on the bar with their bagpipes. (Emmit's.)

Irish pub music does not always mean wistful Celtic melodies. FitzGerald's Nightclub in Berwyn and the Abbey Pub in Chicago often feature American roots and rock music programs of all sorts. O'Banion's, so named for legendary Irish gangster, friend of Bugs Moran, and bootlegger Deon O'Banion, was a punk rock outpost on North Clark Street. It opened in 1978 and closed in 1982 (though the Web site says 1983) having hosted some of the country's most influential punk acts. (Photograph by Ken Mierzwa.)

The late Roseann Kuberski tends bar at O'Banion's in 1981. O'Banion's devotees still hold reunions in the city and connect through Facebook as a way of keeping the bar alive. (Photograph by Ken Mierzwa.)

O'Banion's opened in the spot that once was Johnny McGovern's Liberty Inn, a burlesque/vaudeville joint that employed O'Banion as a waiter. The Liberty also hosted all-black and interracial jazz jams, then a rarity for white audiences. (Special Collections Research Center, University of Chicago Library.)

Bert Kelly's Stables pulled in famous jazz acts before Prohibition shut down the club scene. (Special Collections Research Center, University of Chicago Library.)

The Holiday Ballroom hosted large dances and gatherings for the Irish community in the 1950s and 1960s. (*Irish American News.*)

THE BEST MUSIC
THE BEST DANCING
TWO GREAT BALLROOMS ...

SAINT PATRICK'S NIGHT
SPECIAL ATTRACTION

KEYMEN'S CLUB BALLROOM
4711 W. Madison St.

Irish and American Dancing Every Friday Night

THE IRISH SINGING STAR
PAT McGUIGAN
AND
2 BIG BANDS

BLARNEY CLUB BALLROOM
79th & Halsted Sts.

Irish and American Dancing Every Saturday & Sunday Night

IRISH SINGING STAR
MARY CONNOLLY

THE CROSSROADS OF IRISH AND AMERICAN ENTERTAINMENT IN CHICAGO

The Blarney Club Ballroom was another outpost for Irish music. (Bill King.)

The Irish Village, seen here with owner Jim O'Neill (left) and staff, hosted a number of notable Chicago Irish musicians. (*Irish American News.*)

Tommy Moran stands outside the Irish Village prior to a gig. (*Irish American News.*)

In the 1960s, piper Joe Shannon played pubs all over the Chicago area. (*Irish American News.*)

Joe Shannon (left) plays with Paddy Moloney from the Chieftains. (*Irish American News.*)

At Kilkenny Castle, Irish musicians could go from one pub to another in the neighborhood, including the Atlantic, Dirty Dick's, Ring of Kerry, Glenshesk, and the Abbey. "All of them have since closed but for the Abbey which relocated," Peter Brady said. (Brady family.)

The Castle was the first place in Chicago to hold a performance by Irish music legend Christy Moore. In thanks for the city getting them new instruments, the bar would have holiday time benefits for the Neediest Children's Christmas Fund. More often it featured local talent, including the Dooley Brothers—Mike, Jim, Bill, and Joe—who have remained friends with Brogue over the decades. In fact, the two groups have performed together again in recent years, for old times' sake, at the Irish American Heritage Center. (Brady family.)

At the Castle, the Stroh's and the Guinness flowed. "We were getting a young crowd as well as families," Peter Brady recalled. (Brady family.)

By the mid-1980s, a change came to the neighborhood that made it hard to do business. "Central Avenue became a snow route," said Eamonn Brady (right), seen here with his family. (Brady family.)

Irish luck raised its head, though, as the Chicago Hilton and Towers was looking to open what would turn out to be a trend-setting bar: Kitty O'Shea's, a pub modeled after ones in Dublin. Eamonn Brady said that Benny Martin of the Hilton Corporation and Paul McHugh, the man behind the Irish Pub Company, had even gone to Ireland to look at pubs for ideas and items to bring back to Chicago. "All they needed was an Irishman to run it," Peter Brady said. (Brady family.)

ALLEN RAFALSON ASSOCIATES, INC./PUBLIC RELATIONS COUNSEL
Suite 2500 / 230 North Michigan Avenue / Chicago, Illinois 60601 / (312) 782-0665

FOR: CHICAGO HILTON AND TOWERS
 720 South Michigan Avenue
 Chicago, Illinois 60605.

CONTACT: Kathleen Cap/Mary Jaros

<u>FOR IMMEDIATE RELEASE</u>
May 15, 1986

AND NOW, HEEEEEEERE'S KITTY O'SHEAS . . .

Eamonn Brady, manager of Kitty O'Sheas, brings two decades of Irish entertainment experience to the new Irish entertainment tavern at the Chicago Hilton and Towers. Brady previously operated the family-owned Kilkenny Castle Restaurant & Pub. Kitty O'Sheas will feature live entertainment from 4:30 -6:30 p.m. and 8 p.m. - midnight; Monday through Saturday. International sports will be broadcast via satellite on Sundays. For information, phone the Chicago Hilton and Towers, (312)922-4400.

#

Kitty O'Shea's opened May 15, 1986, and was a hit from the get-go, Eamonn Brady said. "It brought in $32,000 the first 16 days. We would do $2,000–$3,000 a week at the Castle," Eamonn Brady said. Soon Kitty's was the Hilton's first $1 million-a-year hotel bar, and at one time it was its best-performing bar the world over, Eamonn said. (Brady family.)

KILKENNY CASTLE INN
REUNION CONCERT II

BROGUE

and

The DOOLEY

BROTHERS

Kilkenny Castle Inn

Good Food Good Drink
Good Music

THE BRADY'S
MARGARET, PETER, EAMONN

3808 N. CENTRAL AVENUE
CHICAGO, ILLINOIS 60634

The 1990s saw American interest in Irish culture boom just as Ireland was becoming a bigger player on the world scene. Other companies took notice of Kitty's success, including Guinness, which launched "the Irish pub concept," helping entrepreneurs start pubs across the globe. In Chicago, Irish-style pubs began appearing in the city and the suburbs, including The Curragh near Woodfield Mall in Schaumburg in 1998, which Eamonn Brady managed for its first 18 months. (Brady family.)

Eamonn Brady returned to Kitty's in 2000. He's proud that a good many of his staff—most of whom come from Ireland—have made their way into successful hotel and restaurant careers in Chicago. Kitty's location has made it a gathering point after the city's downtown St. Patrick's Day parade, which any Chicago Irish person can tell you is now held the Saturday before (or on) March 17. Dignitaries and do-gooders also amble down from the hotel's grand ballroom, which hosts a bevy of benefits come that most Irish time of year. "All I know is when my wife Traci and I decided to move to Chicago in the 1980s, we were told to head to Kitty O'Shea's in the Hilton. It was one of the best things we could have done. We made and still have a lot of friends from those days, friends who came to Chicago from Ireland like we did," said Shay Clarke, host of the WDCB 90.9 radio show *Blarney on the Air*. (Brady family.)

Irish musician Pat Broaders and Shay Clarke were among the Irish at Kitty O'Shea's on November 4, 2008, the night Barack Obama became the first man of color to become president of the United States. With its proximity to Grant Park, where Obama held his victory rally on that unseasonably warm evening, the Hilton and its Irish pub played host to myriad people who had made their way downtown to witness history. "I couldn't think of a better place to have been," Clarke said. (Shay Clarke.)

Six

The Modern Irish Pub

Gaelic football brought Maurice McNally to Chicago, where he wound up in the pub business.

It was the summer of 1979, and McNally had planned to stay for six weeks, playing for John McBride's club, which had formed in 1956. McNally, then 21, roomed at the home of Chicago Irish matriarch Maureen O'Looney. He wound up meeting his wife, Kathy, at a game in Hanson Stadium on the city's northwest side.

Maurice had been training back home to be a carpenter and found work as a tradesman in the Chicago area, eventually starting his own small business. His wife worked for Richardson Electronics, which moved from the city to far northwest suburban Lafox in the late 1980s.

At the age of 42, with three kids and roots established, McNally came to the realization many immigrants do: "I was never going back to Ireland to live," he said.

A few years later, friend and Irish entrepreneur Shay Clarke started hosting Irish music nights at the now-shuttered JJ Finnegan's in Spring Hill Mall in West Dundee.

These were the mid-1990s, when things Irish were at the height of their popularity, with *Riverdance* sparking interest in traditional Celtic music and dance, albeit with a modern twist provided by south side native Michael Flatley. Clarke helped start an Irish fest at his parish in West Dundee, St. Catherine of Siena. And Finnegan's owner, Paul Leongas, wound up opening an Irish pub near Woodfield named The Curragh, after the horsetrack in Ireland, in 1999, replete with detail work imported directly from Ireland. Retail being what it is, The Curragh made way for a jeweler in 2006 and relocated to Edison Park in 2009.

McNally had opened his own Avondale Custom Homes business in 1992 and was well aware of the trend for all things Irish. He started a bar in St. Charles in 1997.

At the time, businesses such as the Irish Pub Company and Gemmell, Griffin and Dunbar were busy promoting and building pubs designed to have the look and feel of places back in Ireland—the Fadó and Claddagh chains being chief among them.

McNally worked on the concept for his establishment with the Irish Pub Company. While he and his crews did a lot of the work themselves, he imported items from Ireland that provided the feel of authenticity.

McNally wound up having a pub in Elmhurst for a time, too. And he helped build the Irish Cottage in Galena, Bridie McKenna's in Highwood, and (pictured here) McGonigal's in Barrington. (*Irish American News.*)

His most recent endeavors are McGonigal's and the new location for McNally's, both of which opened in 2010. The move from the old McNally's (pictured here) was just a few blocks west down St. Charles' Main Street but brought the pub closer to the center of the suburb's downtown redevelopment. (Maurice McNally.)

McNally brought along many of the features from the original pub (pictured here) to its new digs. Most importantly, he retained key members of his staff, many of whom hail from Ireland. That includes Rosie O'Connell of County Cavan, who has been working at McNally's from its first day. (Maurice McNally.)

O'Connell noted that a secret to the pub's success is being a family-run business and locals making McNally's their local. "Our place is as close to home as it could ever get," McNally said. (Maurice McNally.)

In 2010, as the nation slowly inched its way out of a recession, Bryan McGonigal did his part to stimulate the economy by opening his own pub in a building that was originally a bank that failed during the Great Depression. The First Bank of Barrington was chartered in 1916 and closed in 1932. Over the years, the building, which is close to the town's train station, had been home to a few bank-themed restaurants. (Maurice McNally.)

In fact, working with Maurice McNally, McGonigal built around the bank's vault. McGonigal met McNally through a mutual friend. McGonigal, a third generation Irish American with a sales and marketing background, wound up taking several trips to Ireland researching ideas and seeking items for his cottage-style pub. McGonigal said that crews "pulled everything out of here." The project started in August 2009 and was done in time for St. Patrick's Day 2010. "A lot of feeling went into the place. I wanted it to be like some of my favorite places to go, while giving it a neighborhood feel," McGonigal said. Pictured from left to right are Ted Stay; Tom Kalomiris; Dennis, Bryan, Alexander, and Laura McGonigal; and Damien Dunne. (*Irish-American News*.)

Tommy Nevin's Pub, named for the founder's father, got its start in the back of the Davis Street Fishmarket in Evanston about 20 years ago. It has expanded to include locations in Frankfort and Naperville. (*Irish American News*.)

The Kerry Piper in Willowbrook, also owned by the Nevin Group, hosts traditional Irish musicians. (Dan Larkin.)

U2 cover band Elevation performs at Fadó, a national chain of Irish-themed taverns with an outpost in Chicago's River North neighborhood. (*Irish American News*.)

Staff, customers, and friends are pictured at Johnny O'Hagan's before a charity event in Lakeview. Owner Brendan O'Carroll is on the left, holding the bicycle. (*Irish American News*.)

Not far from Wrigley Field, The Irish Oak, with former owner Billy Lawless on the far right, imported most of its interior fixtures from Ireland. (*Irish American News*.)

Phil Cullen, owner of three Ballydoyle pubs, said his love of Ireland stemmed from an anniversary trip for his parents. "Eleven years ago, I took my parents over to Ireland for their 50th wedding anniversary and fell in love with the place," Cullen said. "I told my brother then that I had to build an Irish pub. So I came home and saved money for a year, and then quit my job. It took two years to talk my friends and family into investing and then to build the pub [in Downers Grove]." He has grown the business to locations in Aurora and Bolingbrook, which opened in 2010. (*Irish American News*.)

As with all trends, what's old becomes new again. When Irish musicians Siobhan McKinney and her husband, Brendan, left their corporate jobs in 1999 to open a pub that reflected their love of traditional music, they looked to Chicago's own Irish history for their venture's inspiration. (Siobhan McKinney.)

In the early 1900s, Chicago police chief Francis O'Neill was a collector of traditional Irish music and devoted his life to preserving and publishing the tunes from his native Ireland. "My husband and I were both inspired by his books and we wanted to honor him," McKinney said. "Music is everything for us and his contributions to Irish music were tremendous." (*Irish American News.*)

O'Neill's portrait hangs over the pub's fireplace and his spirit is evident in the music that fills the building. McKinney said O'Neill's granddaughter visits and approves, as does the heavily Irish American north side neighborhood. "It's important to us to keep the traditions alive, and to have a place where people can come and hear the music of their childhoods," she said. (Siobhan McKinney.)

The key to the successful modern Irish pub, McKinney said, is creating a family atmosphere that welcomes new faces, so that the pub and the music are accessible to everyone. "There are plenty of places where children aren't welcomed or encouraged," she said. "We have classes in Irish music, so people can come and learn with their kids and pass down the stories and the music the way pubs in Ireland do." (Siobhan McKinney.)

Seven

Finding Your Local

In some parts of the country, finding the perfect pub is easy. You leave your home and the closest bar you find, that is it. There is a reason the Irish call the neighborhood pub the local. It is.

In a city like Chicago, with an Irish pub in many a neighborhood and some neighborhoods with several pubs to the block, how do you find yours? How do you choose a second living room, a place to toast your triumphs and ease your tragedies, to host birthday parties and kiss your beloved on New Year's Eve? Simple proximity, in this town, is too reductive a way to deal with the rich array of choices.

Sean Parnell founded the Chicago Bar Project in 2000, researching hundreds of local taverns both in and out of business for an exhaustive online resource at chicagobarproject.com. His book, *Historic Bars of Chicago*, profiled long-running and unique watering holes in the city.

A bar stands the test of time, he said, if the owner has passion for his or her work, creates something unique, and is open to change as the world outside the bar changes.

"My definition of a perfect neighborhood bar is one that you want to keep coming back to, often because of great bartenders, a good crowd, a good beer/wine/scotch selection," he said. "And good food always helps."

Parnell looked back to some of the city's earliest places, like the Sauganash, and found their early character reminiscent of what pubs are becoming today: once again, a place for families to gather and connect.

"What's very interesting to me today, now with a nine-month-old son, is that bars, because they are required to have kitchens or have banned smoking, are becoming more like taverns again," he said. "Families can congregate and linger during the day—eat, have a few drinks, not worry about getting booted out of your table—while the younger, louder crowds come in at night, and there is very little overlap."

Chicago author, actor, and commentator Mike Houlihan, whose one-man show *Goin' East on Ashland* chronicles his years growing up in the city's Irish community, said the personal connection to the pub has meant the most to him.

"When I'm on the south side I hang at Ken's at 105th and Western," he said. "Owner Jackie Casto is half-Irish, his partner Kathy Clancy is 100 percent Irish, and most of the rummies at the bar have Irish blood. I also hang with west side Irish at Kevil's in Forest Park, because my sons tend bar there, and Frank Kevil has actually bought me a drink or two. Downtown, I go to The Gage, because Billy Lawless is a great Irishman who also knows how to buy a drink. North side favorite is the Claddagh Ring on Foster because owner Kevin Clancy is a great host.

"And Schaller's in Bridgeport is the best. Even though the name's not Irish, everybody in the joint is. Other Irish bars that I love in Chicago are any that will let me run a tab."

If you lack a nearby watering hole that is to your taste, however, there are numerous resources available in several media to help you find the kind of place you can feel at home or learn more about the Irish in Chicago.

In addition to authoring *Historic Bars of Chicago*, Sean Parnell maintains the Chicago Bar Project Web site where he chronicles numerous Irish pubs such as Butch McGuire's, seen here with patrons celebrating St. Patrick's Day. (Butch McGuire's)

Barrington McGonigal's Fits Right In

Every Irishman who has ever opened a pub in the winter tries like hell to get it open for St. Patrick's Day. Many fail. Not Bryan McGonigal and his army of qualified help. The Grand Opening was March 12, 2010, and he's never looked back. "Business is good, and the community seems to have embraced us," said Bryan.

Bryan had always wanted to open an Irish pub, and he kept that dream alive for some time. He even went a step farther. In an adjacent but connected building, Bryan and his brother-in-law (Steve Berry) built a beautiful and hip wine bar with its own entrance and ambience. Bryan owns the pub, Steve owns the wine bar, and both share many commonalities such as the kitchen, bathrooms and customers!

McGonigal is third generation Irish from Donegal and has fallen in love with his Irish roots. Bryan and his family imported Irish furniture and bric-a-brac from Derry, and hired Irish transplant, local legend, and pub owner in his own right, Maurice McNally of Avondale Custom Homes Inc., to do the buildout of the pub side. Maurice may be best known as the owner of McNally's Pub in St. Charles, IL, and his pub shares a friendly business affiliation with McGonigal's.

The building is an old historic bank dating back to 1913 which closed during the great depression. The building still retains its great features inside and out such as the bank vaults, one of which is now used as an office, and the main vault area is currently used as a private dining area for 8 to10 guests. Two distinct outdoor dining areas work themselves in nicely, one on each side of the main door. We noticed one was in the sun, and one was in the shade. Made to order!

When you walk in you see a horseshoe shaped bar, a few large televisions if you have to watch TV, but high enough to be out of the way for those who just want some good conversation. You also see the pub has two levels, and areas that tail off to the left that have to be explored. It's almost like being in Ireland with snugs and nooks and crannies, but with an American flair. There is a band area on the first floor where bands and entertainers are scheduled every Thursday, Friday and Saturday nights.

There is also an elevator to the second floor where another large room sports a bar and plenty of tables and TV's for parties, banquets bridal showers or just the overflow crowd on a busy day. This room seats up to 100 and includes a larger band stage which fits 4 to 5 band members.

General Manager Damien Dunne hails from Thomastown, Co. Kilkenny, and has lived in America for the past ten years. Damien and Bryan were hoping to replicate an old style Irish pub (Victorian), and we think they have. The clientele seems to be anything but Victorian with a cross-section of Barrington locals in several age categories. A nice mix for a pub that looks like it is here to stay.

Oh, and the food. It's excellent. It's not a great Irish pub without good food, and we think McGonigals delivers. You'll have to go in and try it for yourself. You'll fit right in!

Word on the street is that McGonigal's could be expanding in the near future. 847-277-7400

www.mcgonigalspub.com or info@mcgonigalspub.com
105 S Cook St, Barrington.

Top picture:
(l to r) Ted Stay, Tom Kalomiris, Dennis, Bryan, Alexander, and Laura McGonigal, and Damien Dunne. *photo by Cathy Curry*

Picture to right:
A great wall mural is one of the decorations on the outside wall of McGonicals on Main St.

General Contractor, Maurice McNally, on the job!

One of several semi-private areas at McGonigal's, called "The Vault."

Back row (l to r): Ted Stay (Executive Chef), Damien Dunne (Pub Manager), Dennis McGonigal (Bryans father and owner of the buildings), Bryan McGonigal (Owner of the pub), and Tom Kalomiris (manager of the sister company, Park Avenue Wine Bar). *Front row (l to r):* Brendon Moratz, Taylor Drewes, Javiar Rodriguez, Alexander McGonigal and Laura McGonigal (Bryan's wife and pub treasurer), Laura Howard, Kyra Brim, Jacklyn Quinney, Evelyn McGettigan, and Neilus O'Connell. *Behind* Evelyn and going back along the far side of bar (r to l): Luis Avila, and kitchen staff Kate Coronado, Rosalinda Magana, Roberto Martinez, Richard Meierdirks (Sous chef), Ernesto Camarena, and Juan Muro. *photo by Cathy Curry*

The *Irish American News*, published in Oak Park by Cliff Carlson, is a free publication available at many, if not most, Irish bars and stores throughout the Chicago metro region. It is a prime source for finding out what there is to do that is Irish in the area. (*Irish American News*.)

Dignitaries, including Taoiseach John Bruton, fifth from right, are pictured just prior to the opening of the heritage center's Fifth Province. The Irish American Heritage Center, 4626 North Knox Avenue, is housed in an old school on Chicago's northwest side. This is as fine a place as any to learn about the Irish in Chicago. On any given Saturday, classes of all sorts are taking

place, including dance and music; volunteers are aiding the cause; and the library is open for the research-minded. The center, which incorporated in 1976, hosts a festival every July, another around St. Patrick's Day, and music most every weekend, particularly in the Fifth Province Lounge. (*Irish American News.*)

Gaelic Park, 6119 147th Street in Oak Forest, has been the south suburban center for Irish culture for more than 25 years. And it is home to a fine Irish festival every Memorial Day weekend that gets the summer started with stories and song. Naturally, it has its own pub, the Carraig, which is Gaelic for "rock." Published in Milwaukee by Martin Hintz, the *Irish American Post* keeps up on the Chicago Irish, too, through the work of veteran journalist George Houde. (Gaelic Park.)

In 2010, the Milwaukee Irish Festival's August gathering along Milwaukee's lakefront celebrated its 30th anniversary. Over that time, the fest had grown to become the largest of its kind in the United States, offering up Irish music, song, dance, culture, food, and drink in hefty Wisconsin-sized portions. That it is so close to Chicago brings Windy City folks north of the border for the fun. (Dan Larkin.)

A number of Irish radio shows are broadcast in Chicago, including *Blarney on the Air* (Mondays, 7 p.m. Central, WDCB 90.9 FM or WDCB.org), *Good Morning Ireland* (Saturdays, 1–3 p.m. Central, 1450 AM or goodmorningirelandradio.com), the *O'Connor Irish Hour* (Saturdays, 11 a.m.–1 p.m. Central, WPNA 1490 AM or irishradiochicago.com), *Chicago Gaelic Park Radio* (Sundays, 7:05–9 p.m. Central, WCEV 1450 AM or chicagogaelicpark.org/Radio_Show.htm), and *The Maureen O'Looney Show* (Wednesdays, 8:30–10 p.m., WCEVE 1450 AM). Pictured is the harp that once stood in the Harp and Shamrock pub, which now resides in the Irish American Heritage Center. (Authors' collection.)

Eight

THE PERFECT PINT, THE PARTING GLASS

Mark Hackett was 14 when he started tending bar. Originally from a small town near Dublin, Hackett was employed at a city disco cleaning out ashtrays and sweeping up glass at the end of the night. One day all the regular bartenders, who had been out on a bender, were too hung over to work, so the managers pushed Hackett into service.

That was more than 20 years ago. He has been pouring pints of Guinness, Ireland's iconic brew, ever since.

The secret to pouring a proper pint, Hackett said, is to have the right temperature and to be patient. This beer flows from keg to glass with a blend of nitrogen and carbon dioxide, which helps account for its bubbly deliciousness. Try to rush your stout and you will end up with a giant glass of foam, Hackett said.

"In Ireland they call it a 99," Hackett said, referring to a cheap ice cream cone bought for 99 cents. "You hand 'em a pint with a big head, and they'll throw it back at you, saying 'I don't want a 99.'"

These days, Hackett tends bar at the Fifth Province, the in-house pub at the Irish American Heritage Center. Customers there, he said, are not impatient for their drinks. Imbibers let him pour a bit, watch the Guinness settle, pour a bit more, let it rest again, and then polish it off with a flourish.

"If you're in a hurry," he said, "this isn't for you."

That attitude, of course, is the key to a good Irish pub.

You cannot be in a hurry. There are plenty of places in America for that. No, at the best Irish places, if you are a regular (like Mike is at Rosie O'Hare's in East Dundee, or Allison is at Healy's in Forest Park), once they see you coming in the door, in a grand welcoming gesture, a good bartender—like beneficent big Ben Mahler is at Rosie's—will have your pint started for you.

Besides, the beer is just one reason you come to a pub. The waiting for your jar gives you time to soak in the scenery. In fact, it would not be too much of a stretch to say that the idea for this book came from years of such experiences, of grabbing a Guinness and gabbing away an evening.

The Irish bars of Chicago—nay, pretty much everywhere—are filled with such conversation. In these days of ASAP social media, you have to be willing to put down your mobile phone for a bit, to leave your computer behind and head out to the still-extant places mentioned in these pages to see for yourself. Make a polite, simple demand of the bartender and patrons at the pubs you choose: tell me a little about your place. Get the conversation rolling, as tradition dictates. Occasionally you might get an odd look. In rare cases, as happened at a surly Bridgeport joint not mentioned until this point in this text, you might even get shown the door. At a good Irish pub, though, they will be happy to regale you with their local lore. (Photograph by Kyle Bursaw.)

At such establishments, do not feel that you have to order a Guinness. Its chocolate coffee bittersweet flavor, like the works of James Joyce, is an acquired taste. Have what you like. Just make sure you stick around for the stories, and be prepared to share a tale or two as well. (Photograph by Kyle Bursaw.)

For in Chicago, you have to give as good as you get. It is part of the deal. It is how friendships, a few fights, and eventually legends get made—with and without accents only natives of either Ireland or Chicago can place, over beer or good food, in bars and restaurants of all sorts, as the city with the big shoulders has an equally ample belly. (Photograph by Kyle Bursaw.)

Sure, this is romanticizing things a bit. That does not make this final chapter a weepy parting glass tipped to end a sappy Celtic romance novel. Nope, this is a guide. Use it. Experience the Irish side of Chicago. (Photograph by Kyle Bursaw.)

Sláinte. (Photograph by Kyle Bursaw.)

ONLINE RESOURCES

chibarproject.com
irishamericannews.com
irish-american.org
chicagogaelicpark.org
irishamericanpost.com
irishfest.com

Another Web guide to Chicago pubs:
barmano.com

A virtual Chicago Irish pub crawl:
kiplog.com/irishmap

Discover Thousands of Local History Books Featuring Millions of Vintage Images

Arcadia Publishing, the leading local history publisher in the United States, is committed to making history accessible and meaningful through publishing books that celebrate and preserve the heritage of America's people and places.

Find more books like this at
www.arcadiapublishing.com

Search for your hometown history, your old stomping grounds, and even your favorite sports team.

Consistent with our mission to preserve history on a local level, this book was printed in South Carolina on American-made paper and manufactured entirely in the United States. Products carrying the accredited Forest Stewardship Council (FSC) label are printed on 100 percent FSC-certified paper.

MADE IN THE USA